# FACTS OF LIFE

## CONTEMPORARY JAPANESE ART

Hayward Gallery

国際交流基金
The Japan Foundation

Published on the occasion of the exhibition *Facts of Life: Contemporary Japanese Art*, coorganized by the Hayward Gallery, London and The Japan Foundation, Tokyo, 4 October – 9 December 2001, as part of the festival Japan 2001

Exhibition selected by Jonathan Watkins
Consultant curator: Nobuo Nakamura
Exhibition organized by Lucy Till and Clare Carolin, assisted by Elena Lukaszewicz and Stuart Tulloch, for the Hayward Gallery, and Atsuko Sato, for The Japan Foundation

国際交流基金
The Japan Foundation

j Japan 2001

Supported in-kind by ANA
A STAR ALLIANCE MEMBER

Catalogue designed by Joe Ewart for Society
Production coordinated by Uwe Kraus GmbH
Printed in Italy

Inside front and back covers:
Shigenobu Yoshida: *08.04, No14, Iwaki*, 2000
VTR, projector. Dimensions variable
Photo by Koichi Hayakawa

Published by Hayward Gallery Publishing,
London SE1 8XX, UK
© Hayward Gallery 2001
Jonathan Watkins essay © Jonathan Watkins 2001
Mami Kataoka essay © Mami Kataoka 2001
Artworks © the artists 2001 unless stated otherwise

The publisher has made every effort to contact all copyright holders. If proper acknowledgement has not been made, we ask copyright holders to contact the publisher.

ISBN 1 85332 222 9

Hayward Gallery Publishing titles are distributed outside North and South America and Canada by Cornerhouse Publications, 70 Oxford Street, Manchester M1 5NH (tel. 0161 200 1503; fax. 0161 200 1504).

# CONTENTS

# FOREWORD

Since its establishment in 1972, The Japan Foundation has been the main organization in Japan promoting international cultural exchange with overseas countries. We have undertaken projects in a wide variety of fields, including the arts and sports. As far as art exhibitions are concerned, we have endeavoured to introduce Japanese art to various countries, organizing or supporting diverse projects, from exhibitions focusing on Japan's traditional arts to those that present works by the world's leading contemporary artists.

  *Facts of Life* features a wide range of participants from veterans to rising young artists. Their chosen media are also diverse, including installations, photography, painting and video. The aim of *Facts of Life* is to show the kind of relationship these artists have with reality and how this is reflected in their works. I believe that it will help to provide a true picture of Japanese contemporary art through each artist's experience of reality.

  In this year of the Japan 2001 festival in Britain, I am particularly delighted that The Japan Foundation has been given the opportunity to organize this exhibition as well as *Shinto: The Sacred Art of Ancient Japan* at the British Museum - two completely different kinds of project, one focusing on contemporary and the other on traditional art. In addition to these exhibitions, a large number of Japan-related events are being held in Britain this year. I very much hope that many British people will visit these various events and that they will stimulate deeper interest in Japanese culture while further promoting friendship and cultural exchange between our two countries.

  Finally, I wish to express my heartfelt appreciation to the artists taking part in this exhibition and to the museums and other owners of works who have so readily agreed to lend to this exhibition. We are especially grateful to our coorganizer, the Hayward Gallery, and to Jonathan Watkins, the guest curator of this exhibition. Last but not least, I would like to express our deep gratitude to All Nippon Airways for their cooperation in transporting artists and their works to London, and to everyone else involved in the organization of this exhibition.

Hiroaki Fujii
President, The Japan Foundation

# PREFACE

The realization of this exhibition - the largest showing of contemporary Japanese art in Britain to date - has long been an ambition of the Hayward Gallery. With a few modest yet pioneering exceptions, and despite the increasing globalization of the contemporary art scene and the high profile of Japanese artists on the international stage, there has been no concerted attempt in this country to examine in depth the complex and dynamic situation in the current art of one of the world's most dominant nations: the Japan of accelerated commercial and technological development may be familiar to us, but any real sense of the culture of the country can still appear distant, and too little known.

In 1994 a major touring exhibition, *Japanese Art after 1945: Scream Against the Sky*, was shown in Yokohama, Japan, and then at the Guggenheim Museum, SoHo, New York and the San Francisco Museum of Modern Art. This seminal exhibition proved a catalyst for the Hayward's project, and focused our interest on a presentation of new work which would acknowledge and assert links with the many and various currents of post-war Japanese avant garde art. Research trips to Japan in the years following deepened our interest and established productive links with artists, curators and institutions there, as did the showing at the Hayward in 1997 of the acclaimed contemporary artist Tatsuo Miyajima, whose work is to be seen here again in *Facts of Life*.

*Facts of Life* does not try to define Japan, or 'Japanese-ness', but instead presents some of the most interesting art being made in Japan today (indeed, at one point, we were strongly urged to call the exhibition "Everything is Interesting"). Since the 1950s, Japanese art has had correspondences with the development of art internationally, but just as British art has a British sensibility, so traits particular to Japan will inevitably emerge in this exhibition. Many of the themes are universal - urban life, social engagement and alienation, a preoccupation with the everyday - but running throughout the show is a sense of wonder at the world around us, and of melancholy about its fragility and transience. *Facts of Life: Contemporary Japanese Art* shows us how extraordinary life can be, but reminds us that little can last.

A fortuitous and appropriate context for the Hayward exhibition has been provided by the planning of Japan 2001, a major nationwide festival of Japanese art and culture. Crucially, this strengthened the basis of our collaboration with The Japan Foundation, co-organizers of the exhibition. The Japan Foundation has embraced the Hayward project enthusiastically from its inception and has provided substantial support; the show could not have been realized without them. We thank especially Munehiro Waketa, Director, and his predecessor Tomoyuki Sakurai, together with Stephen McEnally, Director of Programmes and Junko Takekawa, Arts Programme Officer, in The Japan Foundation's London office for their advice and engagement. We are also grateful to their colleagues at The Japan Foundation in Tokyo who have been

instrumental in bringing the project to fruition, notably Masanobu Ito; Fumio Matsunaga; Masahiko Noro; Hayato Oga; Miki Okabe; Atsushi Oshima; Mana Takatori; Kazuhito Tatebe and Sohei Yoshino. In particular we are indebted to Atsuko Sato, Assistant Director, Exhibitions Division, The Japan Foundation, Tokyo, for her untiring commitment to the details of the exhibition's organization.

Together in 1999 the Hayward Gallery and The Japan Foundation commissioned Jonathan Watkins, Artistic Director of the 11th Sydney Biennial in 1998 and now Director of Ikon Gallery in Birmingham, to develop and curate the exhibition. Jonathan had previously approached Japanese art from an internationalist perspective, and had developed close links with a number of artists. His research and his visits to Japan over the last two years have been key in determining the unique perspective of this project - providing him, as they have, with the opportunity to see fresh work by senior figures and to establish a new set of dialogues and relationships with an emerging generation. Our debt to him for his commitment and energy is immense, as is the pleasure of having worked closely with him. Very special thanks must also go to Nobuo Nakamura, Director of CAA in Kitakyushu and consultant curator to this project, who provided invaluable insights and advice throughout its development.

Together with Jonathan Watkins I should like to thank as well our many colleagues in Japan who received and encouraged us as the project evolved and whose names are listed on page 152. I would also like to acknowledge Masanori Ichikawa, Chief Curator at the National Museum of Modern Art, Tokyo, for kindly inviting me to Japan in 1998, and Yuko Hasegawa, who on the same occasion gave us the benefits of her time, thoughts and contacts.

We should also like to thank most warmly the lenders to this exhibition who have responded so promptly and generously to our loan requests, and who have helped us to resolve various issues arising from the practicalities of each loan. Our particular appreciation goes to Ashiya City Museum of Art and History; Entwistle, London; Fuji Television Gallery; Gallery HAM; HEAR sound art library; Ikon Gallery, Birmingham; Yoshiko Isshiki; Gallery Koyanagi, Koyanagi Fine Art, Tokyo; Nagoya City Art Museum; Masaaki Ogura; Naomasa Okumura; Ota Fine Arts; Otani Memorial Art Museum, Nishinomiya City; Kazunori Saito; Shiraishi Contemporary Art; The Shizuoka Prefectural Museum of Art; Ryutaro Takahashi; Utsunomiya Museum of Art; Voice Gallery and Yokohama Museum of Modern Art.

Thanks must go too to Jonathan Watkins and Mami Kataoka, Chief Curator, Tokyo Opera City Art Gallery, for their illuminating essays, which appear in this book.

On behalf of the Hayward Gallery, I would like to express our gratitude to All Nippon Airways, in Tokyo and in London, who have generously supported the transport and artists' flights respectively for *Facts of Life*.

Closer to home, our thanks go to Joe Ewart of Society for designing this book, Linda Schofield, the Hayward's Art Publisher, for her rigorous attention to its editing and production needs, and Caroline Wetherilt, the Hayward's Publishing Coordinator, for her assistance throughout. It has also been a pleasure to work once

again with David Dernie, who designed the installation architecture. As ever, my thanks also go to Keith Hardy, the Hayward's Head of Operations, Mark King, the Hayward's Installation Manager, and his crew, Imogen Winter, our Registrar, and Nick Rogers, our Transport Organizer, for ensuring the successful delivery of the show within the Hayward Gallery. The exhibition's lighting has been designed by John Johnson and his team at Lightwaves Ltd., Jem Legh and Tom Cullen have assisted us with all technical matters relating to the show's audio-visual aspects. We thank as well Junko Mori for her indispensable help with translations.

We are also grateful to Publicis, the Hayward's advertising agency, for having, once again, created an innovative and arresting promotional campaign, and I particularly wish to thank Lucy Bryn Davis, Ben Carey, Keith Courtney, Henrik Delehag, Daniel Gorlov, Antonia Harrison and Rob Janowski there for the characteristic enthusiasm with which they have approached the project.

Not least, I extend my warmest thanks to all the people at the Hayward Gallery who have embraced this project from the outset and who have played such a vital and indispensable role in its realization, very particularily, Felicity Allen, the Hayward's Head of Public Programmes; Fiona Craig Sharples and Cath Hawes, our Education Coordinators; Helen Snell and Jane Coakley in Hayward Marketing; Karen Whitehouse, Maggie Prendergast, Sophie Dinkel, Meryl Doney and Severn Taylor in Hayward Development; Ann Berni and Arwen Fitch in Press; Pamela Griffin, our Information Officer; and Katrina Crookall, our Planning Manager.

*Facts of Life* has also benefited from a committed and creative Hayward curatorial team led by Martin Caiger-Smith, Head of Exhibitions, who has himself devoted much time and energy to the realization of this complex undertaking and who joins me in thanking the Hayward's own Exhibitions Curators who have led the project through its various stages: Lucy Till, Fiona Bradley and, in the exhibition's crucial last months, Clare Carolin. Particular thanks must also go to Elena Lukaszewicz for her dedicated and stalwart support, Sophie Allen for her assistance with the audio-visual aspects of the exhibition, Clare Hennessy for her help with administration and most especially to Stuart Tulloch for holding everything together. Sally Tallant must likewise be thanked for her input in the later stages.

Finally, Jonathan Watkins and I extend our warmest thanks to all the artists participating in the exhibition, many of whom have produced new work specifically for it, traveled so far to oversee its installation or realization and generously agreed to lend existing works from their own collections. We are indebted to them for their generosity and patience with our enquiries and requests and for their sensitivities to the needs of the project. We are delighted that their work will now be seen prominently here.

**Susan Ferleger Brades**
Director, Hayward Gallery

# FACTS OF LIFE

Jonathan Watkins

There is a refreshing freedom and inventiveness in current Japanese art practice. As opposed to the self-consciousness and academicism of early post-modernism, whereby Japanese culture was celebrated as essentially synthetic, there is now in evidence a distinct aspiration to directness. Notions of Japan as an amalgam of virtual realities, of detached and wonderful fictions, are being effectively challenged through an assertive apprehension of facts of life.

This is not to suggest that a theoretical paradigm of one generation simply has been superseded by another. Many of the artists represented here are established and senior figures in the Japanese art world, such as Yukio Nakagawa, Genpei Akasegawa, Atsuko Tanaka, Takehisa Kosugi and Yayoi Kusama, who have stayed remarkably true to the essential proposition of their work. They remain very influential without becoming distant, and are held in high esteem by many younger artists such as Shimabuku, Rogues' Gallery, Rika Noguchi, Tomoko Isoda, Tadasu Takamine, Navin Rawanchaikul and Takefumi Ichikawa. There is a realism, recently retrieved in cultural discourse, which informs the selection of all the artists in *Facts of Life*.

There is a certain telling use of materials, media and other means of expression that characterizes much contemporary Japanese art. In contradistinction to a belief in intrinsically symbolic values underpinning a 'primal' new-age sculpture, for example, or a technophilia often manifested in futuristic surrealism, it is more economical and eloquent in its familiarity.

Concomitantly, it is highly significant that sculpture is losing ground to those other art forms, including photography and video, which involve the direct trace of actual events. The self-contained art object, in Japan as elsewhere, clearly is on the wane.

The work of Nobuyoshi Araki in many ways epitomizes this shift in attitudes with respect to art. Most famous for his erotic photographs, Araki touches on universal and timeless themes through distinctly Japanese subject matter. His understanding of the message of his chosen medium is clear and his articulation of it intelligent and candid: 'Someone has said that "photography is the medium of death". That as long as you are using photography, you are conscious of death. I react to this by deliberately talking about happiness. I'm not Roland Barthes but "Eroland" Barthes.'[1] Through a pervasive sense of humour, Araki touches lightly, and deftly, on the fact of mortality. Still lifes, urban landscapes, sky studies, nudes and other portraits are all tinged with melancholy as, at the same time, they communicate a relentless vital energy.

Araki often speaks of the continuity between his photography and real life ('photography, life') and this is where his essential strength lies. His later work particularly is not art about art - it deliberately resists 'artfulness' - but rather an unfettered look at humanity and its circumstances.

Araki's insistence on a happy here-and-now is double-edged and not without a strong sense of the temporality which quickly makes the present the past. His punctuation of the photographic mass of *Tokyo Nostalgy* with images of his late wife, Yoko, is perhaps his most poignant gesture to date, and the *memento mori* it prompts is reiterated in the frequent occurrence of flowers as a motif in his work overall. Araki's *Flowers* series exemplifies these ideas and, likewise, the photographs of Yukio Nakagawa, with their imagery derived from the tradition of ikebana, have a beautiful morbidity. The surfeit of petals, the visceral excess, is a concentrated aesthetic dose. Its effect is not unlike that which results from Araki's hyperactive, and arguably cathartic, picture making.

Yayoi Kusama's recent video works, including *Sunflower Passion* and *Gerbera Passion*, depict the artist overwhelmed by flowers. However, it is her video *Song of a Manhattan Suicide Addict*, with her singing in their midst - '... amidst the agony of flowers [where] the present never ends ...' - which explicitly conflates floral phenomena and an easily foreseeable demise. The fragility of the artist's voice, her distracted intensity and the brevity of her song (and thus the work) only serve to heighten the sentiment of the lyrics. But, above all, it is the fact that this is a video featuring the artist herself - the fact that it was her - which makes it such an emotional experience. Kusama's idiosyncratic personal style, completely devoid of mawkish melodrama, recorded, is the key to the strength of this work.

The memorializing quality of photography and related media, as Araki pithily acknowledges, is by no means intellectually untrod territory. Photographic imagery has a kind of melancholy which matches its potential for realism, and a number of contemporary Japanese artists capitalize on the inescapability of this conclusion. The subway photographs of Tomoko Isoda, all entitled *Afterimage*, are taken through the windows at the back of moving trains very early in the morning. This public transport system, overcrowded during peak hours, is virtually uninhabited then, and so the artist, unseen, suggests herself as a solitary figure in a visual field constantly moving away from her. The melancholy is philosophical - the images have an internal logic almost as if derived necessarily from the nature of photography - and any projected narrative is foiled by the geometrical abstraction, combining circular shapes and orthogonal lines, and the functionalism of the architecture of her subject matter.

The settings for Rika Noguchi's work, by contrast, are varied and often involve landscape. They are usually populated by small figures, alone or in small

groups, Friedrich-like in their anonymity to a large extent due to some sort of generic outfit or uniform. Divers, hikers or kite-flyers, for example, *in situ*, they are not posing for the camera, and their behaviour is not remarkable in itself, but the scenarios have a strangeness due to the particularity of their activity and its atmospheric context. The misty slopes of Mount Fuji in *A Prime* are especially evocative. Noguchi does not manipulate her images, either through a choreography of her subject or through darkroom processes, insisting that what she photographs actually happens: 'I wish to photograph the truth', she explains guilelessly, and '... [to find] new ways of looking at the earth'.[2]

Ryuji Miyamoto similarly is concerned to communicate how truth can seem stranger than fiction. Perhaps most famous for his photographs of the Kobe earthquake in 1995, this artist is now working with inverted imagery, and thus mimicking the orientation of visual information as it is received in the human eye – reminding the viewer that the 'right' way up is a trick of the brain. Perceptions are sharpened with this simple gesture, and so *Inside-out-Upside-down (Shibuya)*, a video depicting ordinary street life, prompts a requestioning of basic natural laws. How do people stay on the ground? Why do they get smaller as they get further away? Is walking the most efficient way for them to move? And so on.

Inextricably fused with its perceptual and conceptual challenges is the social commitment exemplified by Miyamoto's realism, most notably in a recent project concerned with the homelessness endemic in Japanese cities. He makes and exhibits large upside-down photographs in wooden 'pin-hole houses', camera obscuras which resemble the desperate shelters made by those with nowhere else to go. The extensive, often beautiful, views they embody – not uncommon from homeless encampments ironically – are in contrast to the cramped circumstances Miyamoto recreates. The cameras also capture a silhouetted image, a direct trace, of the artist himself as he must be present, lying on the floor, in order to make the photographs. The image is a blank human shape in a camera (the Italian word for 'room') which might be easily mistaken for that of a homeless person taking refuge.

Millions live in the suburbs and, increasingly, internationally, this in-between environment is being acknowledged as a cultural crucible. Any built environment shapes its inhabitants as much as it is shaped by them. By focusing on the suburban children of Tokyo, as he does in his most recent photographic series, Takashi Homma raises a corresponding two-part question: what does the future hold for them and what do they hold for the future? Enlarged to a more than life-sized scale, unlike the figures in Noguchi's photographs, the children have an individuality and wilfulness that is clearly visible. Unlike Noguchi's locations, or, equally, those in Miyamoto's *Pin hole* project, the natural habitat of these small human beings is one that is very familiar.

The real world slides into art through photography, as it does through the ready-made, and the difference between art and non-art photographic experience is similarly revealed to be a question of 'grey matter'. When photography becomes its own subject, it runs the risk of undermining itself, of slipping into a spiral of self-referentiality and thereby losing its easy conductive quality. This is not to say, however, that an innocence of the medium is being advocated. Rather, there is a distinct tendency towards a reified acknowledgement of the expressive potential in the nature of photography, its materiality and process. It accounts for the subtlety of much of the work aforementioned, and is epitomized in the work of Hiroshi Sugimoto.

Sugimoto's installation, *Accelerated Buddha*, involves an increasingly fast and blurred succession of Buddha images. These variations on a theme, involving various artisans' signatures or unintentional discrepancies, occurring around an archetypal subject, become dramatically merged, thus communicating the artist's profound interest in the means of visual perception, and a thoroughgoing epistemological scepticisim. Earlier works by Sugimoto depict the sea and cinema screens, reflections of moving light. Whatever he fixes in his photography paradoxically is dissolving in the fluid world it portrays.

The unforced and unpretentious use of natural phenomena in contemporary Japanese art is distinctive, occurring not as the means of representation, but as subject matter sufficient in itself. Like Sugimoto, Shigenobu Yoshida is preoccupied with light and is concerned particularly to communicate the ordinary miracle of the rainbow. He conducts art workshops, often with children and community groups, in which he demonstrates how to make rainbows with a bowl of water and a small mirror. He makes videos of the view through carriage windows during a train journey, holding a prism over the camera lens. The result is captivating as the moving contours and shapes of buildings, trees and other features of the landscape are split into spectral colours.

The work of Takefumi Ichikawa is similarly engaging, fugitive and insubstantial. Consisting of transparent plastic bags filled with helium, it floats in gallery spaces like the ghost of sculpture. As visual art, much of its identity and meaning is derived from its environment, as its environment is literally seen through it.

Ichikawa also writes and performs music, referring to it as 'sound sculpture'. He is one of an increasing number of Japanese artists whose practice embraces both sound and visual media, and this synaesthetic tendency has significant connotations for an evolving understanding of the latter. Firstly, sound is not delimited in a way that plastic artworks are conventionally considered to be. Sound work is not catalogued with respect to spatial dimensions, and is perceived as pervasive and influenced crucially by its context. Secondly, sound is

less prone to 'literary' readings, more abstract and enjoyed for its own sake. It would be wrong to conclude, however, that there is a revival of the kind of dogmatic aestheticism - whereby visual art 'aspired to the condition of music' - which dominated the western late nineteenth century, or post-war modernism. Rather, the emphasis is more phenomenological than artistic, with interest in aesthetic experience that might come from anywhere. In other words, neither Ichikawa nor Yoshida would insist that art is necessary for the aesthetic experience they clearly encourage.

A number of contemporary artists based in Osaka have developed their work around a fascination with inherent - found or ready-made - sound. They are concerned particularly to draw out and communicate the sonic qualities of phenomena normally not thought of as having such potential. These artists suggest that everything has its own music. One of the most succinct performance works by Takehisa Kosugi, for example, *MICRO 1*, involves a piece of paper crumpled and screwed up over a microphone and then let go. The subsequent crackling noise, resulting from the release of tension in the paper, is compelling. Recently, Kosugi has been working with 'contact' microphones, those that pick up sound only if they are in direct contact with another object. It is the sound from the in-between-ness of two objects - 'the marginal zone' - that happens. It is as simple and as remarkable as that.

Yasuhiko Hamachi and Yukihisa Nakase, two artists working in collaboration as Rogues' Gallery, process and amplify the sound of machines. Their most famous work is *Gasoline Music & Cruising*, which involves the application of contact microphones to components of a driven car, including the engine, windscreen wipers and the indicator mechanism. The audience, two at a time, sitting on the car's back seat, is chauffeured by the artists via motorways and treated to their symphony of mixed automobile sounds.

There is considerable diversity in the work of Yukio Fujimoto, ranging from small discreet pieces, such as the *Philosophical Toys*, for example, to performances and sound installations. Like Kosugi and Rogues' Gallery, Fujimoto is making art that encourages a closer scrutiny of non-art life. His *Ears of the Rooftop* project is situated outside the dedicated art space of the museum and involves members of the audience - literally those 'within hearing' - sitting or standing between two long tubes, horizontally extending from their ears. This project shifts and intensifies the sense of hearing, and enhances one's understanding of human sensory experience and physicality. He explains: 'By putting a shell to the ear, the way of hearing sounds around us changes, e.g. by changing the shape of the ear slightly, that happens. Around us various kinds of sounds are flooding and at the same time there exist numerous ears. So long as there are vibrating media, we can enjoy "travels" wherever we may be.'[3] Significantly, not only does Fujimoto focus

attention away from the dedicated space for art, but also he overtly acknowledges the vital role of the audience and what it might bring, even physiologically, to artistic experience.

It is the viewer's expectation of art, brought to the gallery or museum, which Yoshihiro Suda plays on. His wooden sculptures of plant-life are extraordinarily life-like. However, the meticulous craftsmanship, and the nature of the subject matter and placement, resulting in a momentary double-take, is by no means intended as a demonstration of technical virtuosity, or as a witty observation on the nature of artistic representation. Rather it is offered as an opportunity for meditative thought on the world beyond oneself, ideally to merge with it. The philosophy that informs Suda's work is thus the opposite of transcendentalism.

The concentration involved in Suda's work, inviting the closest look at natural phenomena, bears resemblance to the careful figurative drawings of Yuji Watabe. This young artist draws in pencil full-length portraits directly on to the wall. Using photographic projection often as a guide, and a linear style which tends to emphasize the contours of his subjects, he recasts the classical legend of the birth of art whereby the profile likeness of a lover is captured through the tracing of an outline of a shadow. Watabe not only capitalizes on the efficiency of photography, but also evokes the same melancholy and ubiquitous sense of time passing. And, like Suda, he deploys a technique that is clearly time-consuming and conducive to an awareness of temporality in general. Craft-oriented art practice, and likewise photography and still life motifs – all of which are combined in the work of Yukio Nakagawa – implies the countdown which silently accompanies real life.

Tatsuo Miyajima explicitly refers to human mortality through LED digital counters. One of his most recent works, *MEGA DEATH*, embodies a sublime beauty paradoxically in order to articulate a primary concern with human-wrought catastrophe. 24,000 illuminated countdowns, with numbers diminishing at different rates, could be simultaneously switched off, plunging the audience into a darkness which alluded to the mass slaughter of modern warfare – brought to an awful climax by the atomic bombing of Hiroshima and Nagasaki. Miyajima, whose earlier work was often public performance, is now returning to an art practice that is more imperative in nature, requiring the active involvement of audiences. *Floating Time*, the installation of LED countdowns shown here, projected from the ceiling, cannot be experienced passively. It has to be walked through, in order to be experienced at all, and so the viewer is implicated.

One of the most powerful images of modern art is a photograph, taken in 1956, of Atsuko Tanaka wearing her *Electric Dress*. The artist was participating in the second exhibition of the radical Gutai artists' group in Tokyo, covered head to foot by a panoply of light bulbs, fluorescent tubes and electric cables. Like

Miyajima, she was highlighting the strange conflation of humanity and its technology, still very much in the shadow of the atomic bombings and the subsequent American occupation. Most immediately, she was responding to the neon signs of a brave (complicated) new metropolitan Japan, but arguably the implications resonate now even more than they did in the 1950s.

In 1957 Tanaka stopped making works which actually involved electric light, but her paintings since then, consisting of circles of vibrant colour connected by dripped and drawn lines, have continued to suggest electronic circuitry. They are extraordinary as they refer at once to their inspiration and the process by which they are made. And not only are the artist's physical actions, the movement of her body as she applies the paint to a canvas on the floor, manifested in the work; so too is a certain biomorphism. The configurations equally refer to animal/human circulatory and nervous systems – these in turn are reflected in our various social organizations – and so the viewer cannot avoid identification with the nature and subject of Tanaka's paintings.

*Inertia*, a video projection by Tadasu Takamine and Masashi Iwasaki, like Tanaka's *Electric Dress*, involves the uneasy combination of a young woman and modern technology. In this case, the woman is seen lying, close-up and feet first, on top of an express train. The exhilarating way in which the rest of the world flashes past, the fast rhythmic ambience of the railway structures and the powerful electric hum of the train itself dramatizes the fruitless modest gesture of the woman pushing her dress down over her legs against the force of the wind. The situation is intensely sexual, unstoppable and breathtaking, blatantly derived from classic fetishism and Freudian dream/nightmare scenarios.

Tomomi Maekawa makes figurative paintings of aeroplanes in large skies, ostensibly communicating her understanding of a tragic and futile male heroism. They constitute abstractions of her experience of living within proximity of an American airforce base as a child, but, beyond that, they share feelings of oddness that are unmissable also in the work of Noguchi and Isoda, and Tanaka and Kusama as women artists of an older generation. They *are* odd. Maekawa's military aircraft, usually flown by men, provide an effective analogy for a general tendency, and it cannot be stressed enough how essentially male the established Japanese art world has been.

Born in Chiang Mai, Navin Rawanchaikul has been living in Fukuoka, Kyushu, for several years. He has developed a practice which not only betrays his Thai origins, but also is characteristic of a local tendency towards collaboration in the production of art work. The involvement of other individuals, or communities, in his projects, which in turn encourages audience participation, reflects an unusual generosity and an assumed social role for art. In his various forms of exchange with his audiences, Rawanchaikul, like Borges, suggests the equally

imaginative lives that can be led by non-artists. The same is true for Tokyo-based artist Makoto Nomura who uses music as a medium for constructive cooperation.

Shimabuku often collaborates with Nomura. Their participation together in a recent exhibition at Tokyo Opera City Art Gallery, for example, involved the donation of some of their allotted gallery space to the work of younger or less established artists.[4] Nomura conducted music workshops there, on cushions on the floor, for members of the public, and Shimabuku similarly inhabited the space as an occasional artist-in-residence. An atmosphere of openness and easy informality was as much part of their work as any tangible result.

Shimabuku's work in general has a whimsical quality derived from spontaneous encounters and investigations of seemingly arbitrary subjects. His search for a legendary 165-metre-long mermaid, during 1997 and 1999, for example, took him from Kyushu to Marseilles to Sydney, not in a belief of apprehending the creature, but instead to make countless other discoveries on the way. These were manifested in subsequent installations combining children's mermaid drawings, traditional French marquetry, recordings of Aboriginal music dedicated to water spirits, video documentation of the Sydney Harbour Bridge, matching its dimensions to a rope 165 metres long, and so on. The journey is a recurrent theme for Shimabuku, who travelled on the Grand Union Canal from London to Birmingham last summer making pickled cucumbers, and, more recently, from the Akashi Sea, near Kobe, to Tokyo with a live octopus. The latter was a return journey, finishing back in the sea, and was touristic as it included a visit to the landmark Tokyo Tower and Tsukiji, the city's famous fish market.

Shimabuku's identification with the octopus is poignant, and he describes the journey as his own 'Apollo Project'. The meticulousness with which he undertook it – as with all his projects, in the face of an assumed universal absurdity – makes it existential in nature and more vital through its engagement with everyday life. In this respect Shimabuku's work is not unlike that of Go Watanabe. The unresolved, Sisyphean scenes he sets up for his short video pieces strike a chord through their domesticity. For example, there is the constant creation and dismantling of situations – making beds, laying tables and so on – which occur in everyday life, or the sequence of vignettes focusing on small messes inadvertently made in the course of normal household activities. His *Drill Man* video perhaps is most touching. Here the artist is seen using an electric drill which unplugs itself, due to the just-too-shortness of the lead, over and over again, as he attempts to make a hole in a wall.

Genpei Akasegawa, a member of the acclaimed Hi Red Centre artists' group during the early 1960s, now is as active as ever, particularly in his writing and photographic activity. His ongoing series, the *Thomason* photographs, takes its title from the story of a fêted American league baseball player, transferred to a

Japanese club, who never fulfilled his promise. It constitutes an archive of gentle images, depicting coincidences and other situations that, like Joycean epiphanies, are as meaningful as they are undesigned. A staircase that leads to non-existent doors, for example, a puddle that forms in a concrete footprint, or a road sign which appears to be directing traffic through a small hole in a sheet of corrugated iron – these are things which the artist has actually seen. Funny, affecting, transient, but fixed in photographs, they are facts of life he wishes to share with us.

## Notes

[1] 'Interview with ARAKI Nobuyoshi', *ARAKI Nobuyoshi: Sentimental Photography, Sentimental Life*, exhibition catalogue, Museum of Contemporary Art Tokyo, 1999, pp. 74-75

[2] See Shimabuku, 'A man who walks to Universe', *Seeing Birds. Rika Noguchi*, P3 art and environment, Tokyo, 2001, unpaginated

[3] Yukio Fujimoto, 'Ears of the Rooftop', *Yukio Fujimoto. Object, Installations and Performances*, exhibition catalogue, Otani Memorial Art Museum, Nishinomiya City, 1998, p. 58

[4] *Encounter*, Tokyo Opera City Art Gallery, January – March 2001

# THE UNKNOWN POWER HIDDEN IN REALITY
Mami Kataoka

In the professional baseball world, the Japanese star batter Ichiro has been unstoppable since he crossed over to the Major League in the United States, while in the world of soccer, midfield star Nakata made news when he transferred from Rome to Parma in the Italian Series A League. It is only natural that Japanese fans should be excited by the exceptional performances of these athletes overseas, but the most pleasing aspect of their success is their unaffected attitude. Even though they have achieved international stardom, they do not let the audience see how hard they have worked to get there nor do they make an excessive display of emotion. Ichiro and Nakata have gained worldwide recognition while remaining very much themselves. Of course they are both very talented, but there is still a clear difference from ten years ago, when Satoru Nakajima made his first appearance in a Formula 1 race. Even though Nakajima was never among the leaders, his completing the race was enough to satisfy the Japanese fans. Individuals who not only appear on the world stage but become recognized presences there gain an identity that transcends such facts of personal history as nationality or gender.

In this age of globalization and multiculturalism, the culture imported into Japan from overseas and the pop culture that Japan exports, exemplified by karaoke, animated cartoons and Pokemon, coexist with traditional culture in a multi-faceted society. This ambivalent and chaotic culture also represents everyday reality for the people who live here. In terms of geographical distance, Japan is viewed by westerners as 'the Far East', but now that overseas travel has become commonplace and the internet has provided a window onto the world, the psychological distance between East and West has been decreasing.

In the last fifteen years or so, the history of Japanese avant-garde art has been investigated in the West through such milestone exhibitions as *Reconstruction: Avant-Garde Art in Japan 1945-1965* (Oxford, 1985),[1] *Avant-Garde Japan 1910-1970* (Paris, 1986),[2] and *Gutai: Action and Painting* (Madrid, 1986).[3] This trend can be viewed as part of a natural attempt at a comprehensive reappraisal of the twentieth century as its end came into sight.[4] Beginning in the late 1980s, however, exhibitions such as *Against Nature* and *Primal Spirit*, which toured the United States in 1989 and 1990 respectively, presented the current work of contemporary Japanese artists. The artists featured in these exhibitions did much to raise the level of international recognition of Japanese contemporary art at the time, especially a group of artists born in the mid-1950s including Tatsuo Miyajima, Yasumasa Morimura, Katsura Funakoshi, Tadashi Kawamata and Shigeo Toya. Leaving aside the international interest in cosmopolitan artists of the previous generation, such as On Kawara and Shusaku Arakawa, the appearance of these artists

presaged a new phase in Japanese contemporary art. Furthermore, the exhibition *Scream Against the Sky: Japanese Avant-Garde Art After 1945* (Yokohama Museum of Art, 1994)[5] covered the whole post-war period from Gutai, Tokyo Fluxus and Hi Red Centre in the 1950s and '60s, through the Mono-ha and contemporary abstract painting to the artists of the 1990s. This study of Japanese avant-garde art established historical links with the new generation of artists such as Yukinori Yanagi and Kodai Nakahara.

In the 1990s, when monolithic ideologies had nowhere to go following the collapse of the Cold War structure, contemporary art also entered a period of diversification. While it became difficult to find a dominant trend, interest grew in Asian, East European and African contemporary art, and exhibitions of Asian contemporary art have been frequently held in Japan since the beginning of the 1990s. Since it has become common practice for artists to travel to the exhibition venue and set up site-specific installations, and residence and exchange programs are becoming increasingly popular, Japanese artists are also taking part in exhibitions that transcend national boundaries, through meetings and discussions with curators in person. The *Donai yanen!* Japanese contemporary art exhibition (Paris, 1998)[6] introduced the works of young artists with little experience of exhibiting, even in Japan. It suggested that each artist, not necessarily as a 'Japanese artist' but as an individual, was beginning to be recognized as someone sharing the contemporary moment. The foreign curators had the knowledge and experience to look beyond the simple exoticism of 'the Far East'.

*Facts of Life* is refreshing in that it is neither a historical verification of Japanese contemporary art nor an evocation of a particular artistic movement or generation. Rather, it is an attempt to present contemporary art from the 'life-size' perspective of how artists living in the present day grasp the reality of their lives and translate it into art works. The participating artists span a wide age range, from the oldest, Yukio Nakagawa (born in 1918), to Atsuko Tanaka, one of the leading artists of the Gutai group,[7] Genpei Akasegawa, Takehisa Kosugi, and Yayoi Kusama, who were all active on the front line of contemporary art in the 1960s, to artists now only in their late twenties. The current reappraisal of the artistic movements of the 1960s is by no means confined to Japan. However, recognizing the links between different generations of artists through the fact that they are all vividly expressing themselves as a reflection of the same age, gives us a comprehensive view of the current state of post-war Japanese art and also a sympathetic understanding of the realities experienced by each of these artists as fragments of lives that transcend space and time.

When artists born from the 1960s onwards commenced their artistic activities in the 1990s, Japanese society was entering its longest post-war recession after the collapse of the bubble economy. This generation looked askance at a society

pulled up and down by an economy that boomed beyond its real stature and then collapsed. As a result, these artists do not put their faith in illusory, bubble-like values, nor do they become completely immersed in pleasure; they have acquired an attitude of 'creative recycling' that discovers new value in everyday surroundings or things that seem to have no apparent use. Their motivation does not spring from any antagonism towards conventional systems or structures. Accepting their surroundings as a given, some of them create works that express a sense of 'nothing in particular happening' as everyday reality, while others allude to an art market or system whose frailty they have become painfully aware of, and others still address the theme of transience of the 'floating world'. They reconfigure their surroundings within their respective contexts, justifying these attempts with Fluxus-like concepts or the anti-art stance of the Neo-Dadaists and Hi Red Centre in the 1960s.[8]

James Roberts, in the catalogue to a show of contemporary British art, wrote, 'Partly because of this lower-key approach in the face of recession-hit Britain, and partly in reaction to the didactic nature of much art of the late 1980s, many younger artists' work has taken on a more modest aspect and addressed important themes not through dramatic gestures, but through engagement with the everyday'.[9] It would seem that this is an international trend, not one confined only to Britain. The titles of a series of annual exhibitions started at the Museum of Contemporary Art Tokyo in 1999, such as *Modest Radicalism* and *Cold Burn*, are indicative of this new trend, and the relatively modest size and feel of the works also constitute a style that is to some extent symbolic of the age.[10] It is interesting to note, however, that while artists like Takashi Homma and Rika Noguchi capture the banal flow of everyday time without revealing much personal emotion and convey the quiet tales of the subjects in their works, which is indeed one of the characteristics of this new generation of photographers, they have been strongly influenced by an artist such as Nobuyoshi Araki, who directly expresses the ebb and flow of everyday feelings including those from his own private life. The current style of 'private photographs' by this same young generation of photographers, shows the same deep personal involvement and 'humanness' as in Araki's work, which gives them a sense of liberation and opens their nihilistic attitude towards the surroundings.

The acceptance of a given, albeit transient, reality reflects the urge both to yield to something outside oneself without manipulating the flow of time and to continue questioning the meaning of each 'life'. One can sense the vital force underlying the powerful and sensual expression of life and death in the works of the ikebana artist Yukio Nakagawa, who stands proudly aloof from any particular movement or trend, and in the voluptuous plants and human subjects in Nobuyoshi Araki's photographs. One can also discern a yielding to an invisible, external power in the art of Shigenobu Yoshida, who employs the prism effect to make us

appreciate anew the light that colours everyday scenes. Similarly, Yoshihiro Suda, who uses the traditional medium of wood sculpture to create life-size flowers and leaves for installations that are reminiscent of paintings with large areas of blank space.

Tatsuo Miyajima, who has been at the forefront of Japanese contemporary art for more than ten years with his consistent exploration of concepts such as 'keep changing', 'connect with everything', and 'continue forever', has represented 'time' and human 'life' in his works using LED gadget counters as well as through solo or interactive performances. The ambiguity and duality in his work maintains a balance in the long temporal cycles of his works.[11] Atsuko Tanaka, an artist associated with the Gutai group in the 1950s, has continued over the last forty years to create unique paintings with images of light bulbs and electric wiring.[12] It is interesting to know that Tatsuo Miyajima has long admired the work of Tanaka, who has pursued a direct and consistent artistic expression as a means of simply communicating facts about her own life independent of the many artistic movements and trends over the last half century. A sense of the unbroken passage of time is also evident in Hiroshi Sugimoto's photographs, which capture the tranquility of a horizon or cinema by long-time exposure, and in Ryuji Miyamoto's photographs, which explore the process of urban deterioration.

The same perspective of discovering new value in the everyday is apparent also in Michihiro Shimabuku's approach as an artist: he establishes an imaginary objective and spins a tale from the meetings he has with people in the process of achieving it. The method of developing a work through direct communication with others has received particular attention in recent years, which may be an indication that we still desire a sense of intimate distance or face-to-face encounters in reality even though we are connected with the whole world via the internet.

Yayoi Kusama, who went to live in New York in 1957, is another artist who has steadfastly pursued her own motifs and is still very active today. This passionate commitment fully justifies the reappraisal her work has been undergoing in the United States and Europe in recent years. Through his involvement with the Neo-Dada Organizers in 1960, which he started together with Shusaku Arakawa, followed by Hi Red Centre[13] and the *Yomiuri Independent Exhibition*,[14] Genpei Akasegawa passed through various phases of visual expression in the early 1960s, both as an individual artist who was indicted on charges of fabricating thousand-yen bills with which he packed various objects and then exhibited, and as a member of these important artists' groups. Looking back on his activities in the 1960s, he commented: 'Through our understanding that those weren't ordinary paintings but merely everyday objects, we were perhaps discovering the shortest distance between painting and real life'.[15] According to Akasegawa, the destructive energy of that time was, unlike that of Dadaists such as Marcel Duchamp and Man Ray, something

quite spontaneous: 'Following a route that developed naturally within us, we got to know what objects are with our bare hands'. Subsequently, Akasegawa, as well as doing a great deal of writing, has pursued such activities as 'Rojo Kansatsu Gakkai' (the roadside observation society), a field survey group composed of architect Terunobu Fujimori and illustrator Shinbo Minami amongst others, which searches for, and photographs, useless, out-of-date objects as hidden expressions of street life, later named the 'Thomason' series in 1982 (the first object, 'Stairs in Yotsuya' was found in 1972) that re-evaluated them, and the 'Leica Domei' (Leica Alliance), in which he takes humorous photographs of the town, with photographer Shin Takanashi and artist Yutokutaishi Akiyama, using a manual Leica camera. Yet, whatever he is doing, the underlying theme of his aesthetic approach is the search for tiny diamonds glittering among our ordinary everyday surroundings. With his humorous and refreshing outlook on society, Akasegawa presents us with new worlds, as described by Tetsuo Matsuda, 'Rather than dualisms such as authority/anti-authority, art/anti-art or violence/non-violence, he penetrates the grey area between these extremes and opens up new horizons such as non-authority or super-art'.[16] In his recent book, *Rojinryoku* (Old People Power),[17] Akasegawa's aesthetic of observing the everyday and 'going with the flow', rather than becoming attached to it, has again brought him under the spotlight and his work has gained considerable support beyond his own generation.

Finally, in the words of Yukio Nakagawa, now over eighty years of age, we can again see the essence of life transcending time: 'If you can make a flower something of your own, you open the way to new perspectives and ways of thinking. By discarding the parts that can be discarded, you bring new aspects into view. Things you couldn't see before become visible. Though it's the flower that teaches you this, it's essential to develop a receptive mind that can communicate with flowers. With this flexible mind you see, feel and experience the joy, suffering and sadness of people living today. It's important to express your own present feelings. If you don't, living today has no meaning'.[18]

When we attempt to discuss the culture of a country, we often pursue its uniqueness and distinctiveness, tending to lose sight of the fact that the world is connected by contemporary values. We should not pretend to overlook the particular malaises or negative aspects of each society, but we should be receptive to the age on a global scale by accepting reality as we find it and developing new values. At the same time, by directly confronting each individual's 'facts of life', and sharing the time and reality of others through one's own experience and imagination, we may be able to make much of the potential of living together. The acceptance of differences is imperative in this global time when we increasingly encounter different cultures on an everyday basis.
(translated by Richard Sams)

## Notes

[1] Museum of Modern Art Oxford, 8 December 1985 - 9 February 1986; Fruitmarket Gallery, Edinburgh, 22 February - 5 April 1986.

[2] *Japon des Avant Grades 1910-1970*, Musée national d'Art Moderne, Centre Georges Pompidou, Paris, 1 December 1986 - 2 March 1987

[3] *Grupo Gutai: Pintura y Acción*, Museo Español d'Arte Contemporáneo, Madrid, 21 December 1985 - 26 January 1986; *Gutai: Akcija i Slikarstvo*, Muzej Savremene Umetnosti, Beograd, 27 March - 4 May 1986, later travelled to Hyogo Prefectural Museum of Modern Art, Japan. Including many other exhibitions such as *Avant Garde Japan - The Gutai Group* in the 1950's, National Gallery of Modern Art, Rome, 6 December 1991 - 28 February 1992, the Gutai group is probably the most frequently presented Japanese artistic movement overseas. The Gutai Art Association was formed in 1954 by Jiro Yoshihara as a leader and other artists mainly from the Kansai region. The artists' creative use of materials and their unique artistic activities were first introduced to the West in 1957 by French critic Michel Tapie.

[4] In Japan, several comprehensive exhibitions of post-war art were held in the mid-1990s, including *The Locus of Post-War Culture 1945-1995* (touring exhibition, Meguro Museum of Art, Tokyo, 1994, etc), *Light-Up in 1953 - The Image of a New Post War Art Becomes Visible* (Meguro Museum of Art, Tokyo, 1995), *A Turning Point in Japanese Art* (Museum of Contemporary Art Tokyo, 1996), and *Japanese Art, 1960s First Phase: Japanese Summer 1960-64 'I Don't Give a Damn Anymore!'* (Art Tower Mito, 1997).

[5] Held the following year at the Guggenheim Museum, New York.

[6] *Donai yanen! Et maintenant! La creation contemporaine du Japon* (Ecole Nationale Superieure des Beaux-Arts, Paris, 1998)

[7] See note 3.

[8] The artist Takashi Murakami, who also runs the studio Hiropon Factory, made the following comment about Fluxus founder George Maciunas: 'Art as a business. That's certainly worth trying'. Tsuyoshi Ozawa, who has taken part in many overseas exhibitions, said of his own performance activities: 'There's no meaning and I never practiced beforehand - doing it all as a kind of gag was something I learned from Fluxus'. The 'Showa 40 Club', a group of artists born in 1965, shows the influence of Fluxus in the freedom with which the members move in and out of the group. Furthermore, the use of milk cartons reflects an awareness of the Fluxus-like concept that things 'must be mass produced and cheap'. *Studio Voice*, INFAS, April 1995, vol. 233, p. 46.

[9] James Roberts, 'What's the Story...?', *Real/Life: New British Art*, catalogue for an exhibition coorganized by the British Council and the Asahi Shimbun, 1998, p. 15 (toured to five venues including Tochigi Prefectural Museum of Fine Arts, 12 April – 31 May 1998; Museum of Contemporary Art, Tokyo, 10 October – 13 December 1998; Ashiya City Museum of Art and History, 15 January – 4 March 1999).

[10] When Japanese contemporary art is viewed from a western perspective, Takashi Murakami, Mariko Mori and Yoshitomo Nara are probably the artists who get the most exposure as symbolizing Japanese contemporary culture. Yet it is interesting to note that these artists, who have all lived overseas, in fact have found their sense of reality in the popular culture of their homeland.

[11] According to Miyajima, who has strongly influenced other Japanese contemporary artists, 'Ultimately "what is Japanese" is determined by the framework of an age rooted in its cultural climate: "what is Japanese", therefore, is very diverse... In this context, the individual is formed through his or her interaction with the age and its cultural climate'. Tatsuo Miyajima, 'On "What Is Japanese"', *Art as a Question Mark*, 1999, chap. 2, pp. 200-03.

[12] A large-scale retrospective exhibition, Atsuko Tanaka - *A Search for an Unknown Aesthetic, 1954-2000*, was held in 2001 at Ashiya City Art Museum (3 March – 6 May) and Shizuoka Prefectural Museum of Art (28 July – 9 September).

[13] Hi Red Centre was an avant-garde artists' group established in 1963 and named after the first letters of each member's family name, Jiro Takamatsu, Genpei Akasegawa and Natsuyuki Nakanishi, translated into English (Taka = high, Aka = red, Naka = centre).

[14] This was an annual exhibition started in 1949 and based on free submission in opposition to the groups of 'salon' art which resumed after and the war. It was dis-continued in 1964 due to the overheated self-destructive energy of its last few years.

[15] Genpei Akasegawa, 'Inside Self-Destroyed Painting', *Art Vivant*, Seibu Art Museum, 1986, no. 21, p. 93.

[16] Tetsuo Matsuda, 'The Collapsed Center', *Genpei Akasegawa's Adventure (Virtual Resort Development Strategy)*, exhibition catalogue, Nagoya City Art Museum, 1995, p. 151.

[17] Akasegawa defines 'old people power' as 'the unknown power hidden in phenomena such as forgetting things, repeating yourself, and sighing, which have hitherto been shunned by society as senility, paralysis, and dotage'.

[18] Interview with Yukio Nakagawa, 'Special Feature 2: Yukio Nakagawa', *BT: Bijutsu Techo*, October 2000, vol. 52, no. 794, p. 114.

ARTISTS

# Genpei AKASEGAWA

cat. 3
*Diary* 1984-86

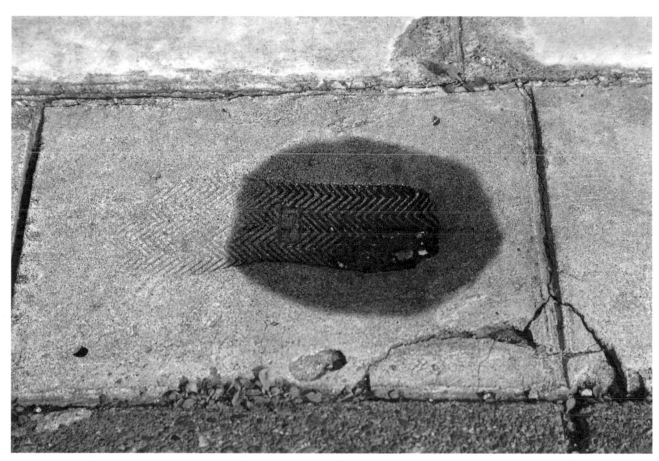

fig. 1
*A weighing machine after rain* 1986
from the series *Unidentified Objects*
photograph (c-print)
44.7 x 54 cm
Collection of the artist
Courtesy of Nagoya City Art Museum,
Shiraishi Contemporary Art

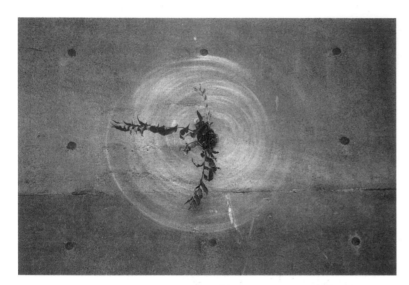

fig. 2
*Plant wiper (full round type)* 1988
from the series *Unidentified Objects*
photograph (c-print)
44.7 x 54 cm
Collection of the artist
Courtesy of Nagoya City Art Museum,
Shiraishi Contemporary Art

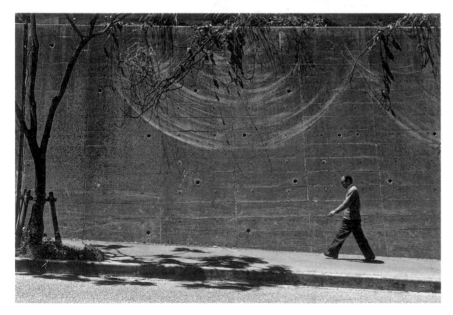

fig. 3
*Plant wiper (grand type)* 1988
from the series *Unidentified Objects*
photograph (c-print)
44.7 x 54 cm
Collection of the artist
Courtesy of Nagoya City Art Museum, Shiraishi Contemporary Art

fig. 4
*Shadow tree* 1986
from the series *Unidentified Objects*
photograph (c-print)
44.7 x 54 cm
Collection of the artist
Courtesy of Nagoya City Art Museum,
Shiraishi Contemporary Art

fig. 5
*Flower painting* 1992
from the series *Unidentified Objects*
photograph (c-print)
44.7 x 54 cm
Collection of the artist
Courtesy of Nagoya City Art Museum, Shiraishi Contemporary Art

# Nobuyoshi ARAKI

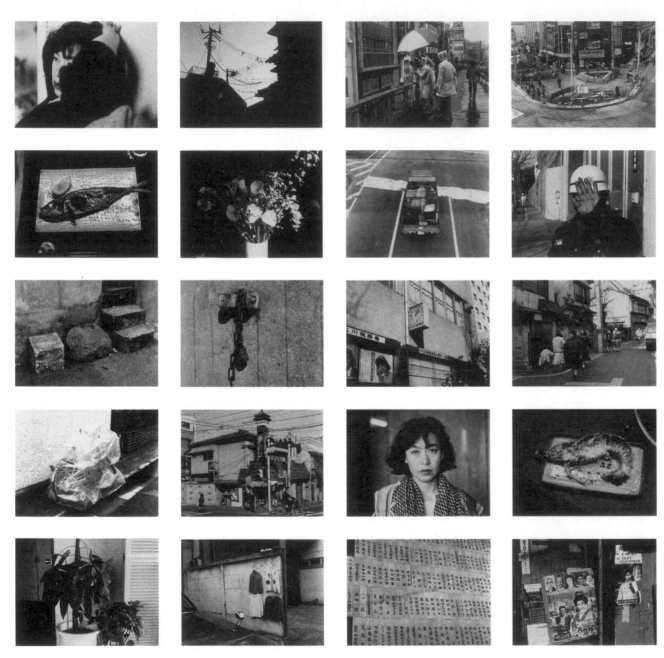

cat. 4 (pp.32-34)
from the series *Tokyo Nostalgy* 1985-93

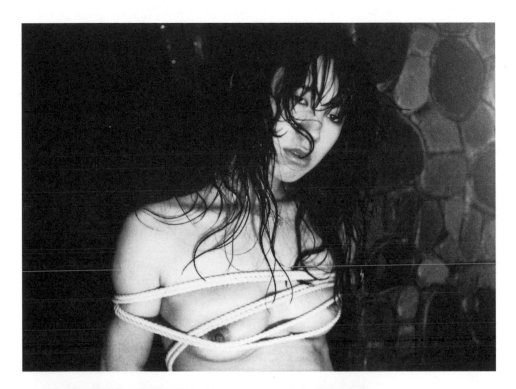

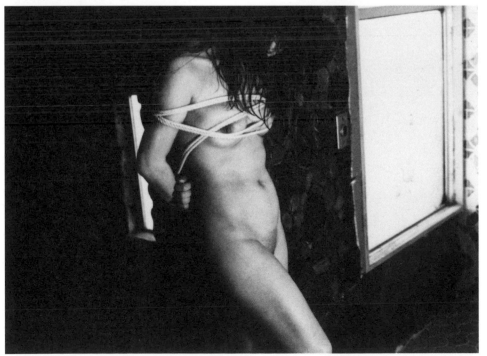

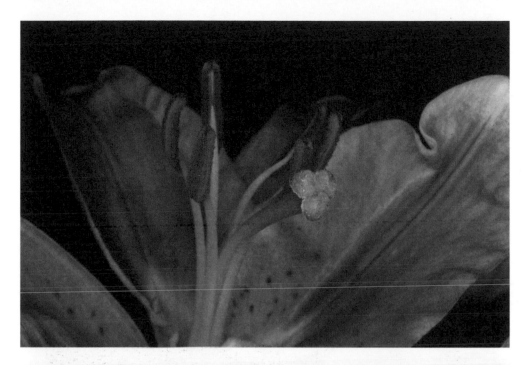

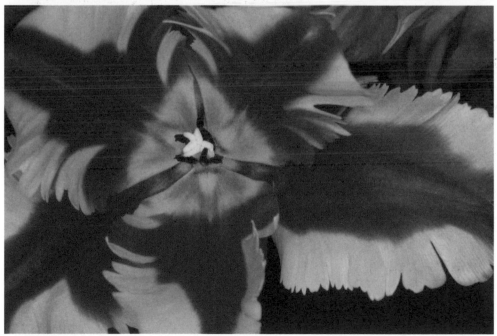

cat. 5
from the series *Flowers* 1988

Yukio **FUJIMOTO**

cat. 6
*Hermetic Scale (Diameter)* 1988

cat. 11
*Cosmos (Black)* 1998

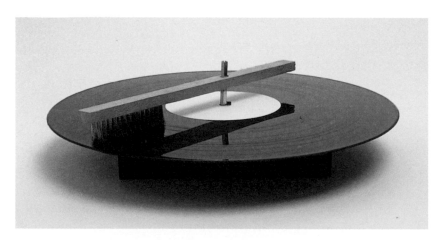

cat. 13
*Record* 2001

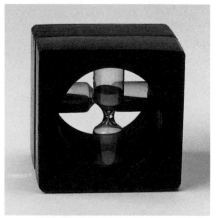

cat. 9
*King & Queen* 1990

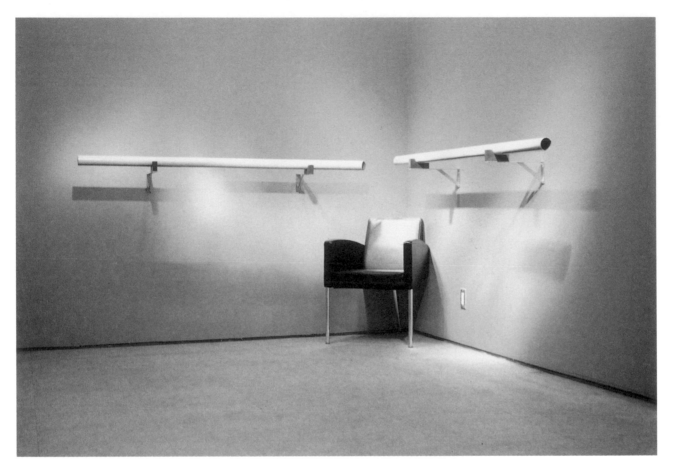

fig. 6
*Ears With Chair, Ear Pipe - Inside Version* 1990
vinyl chloride, wood, iron, chair
dimensions variable
Collection of the artist
Courtesy of Otani Memorial Art Museum, Nishinomiya City
photo: the artist

Opposite:
fig. 7
*Ears With Chair, Ear Pipe - Outside Version* 1990
vinyl chloride, wood, iron, chair
dimensions variable
Collection of the artist
Courtesy of Otani Memorial Art Museum, Nishinomiya City
photo: the artist

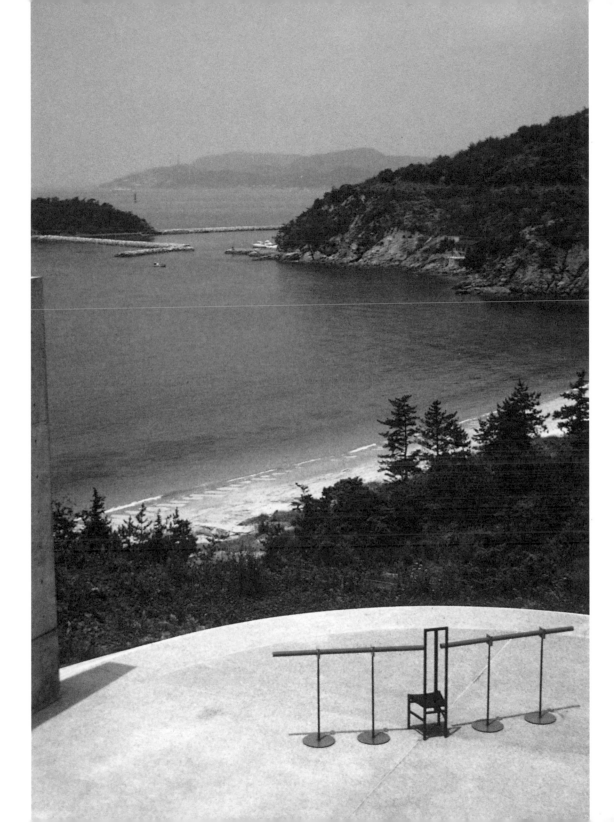

Takashi  <u>HOMMA</u>

cat. 15 (pp.40-43)
from the series *Children of Tokyo* 2000-01

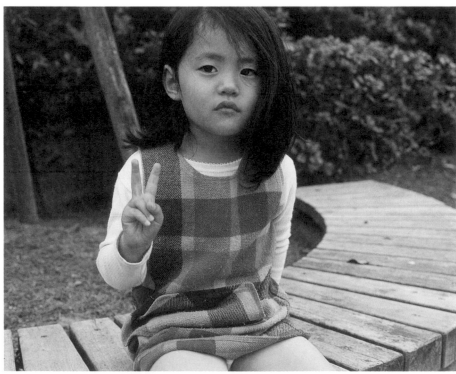

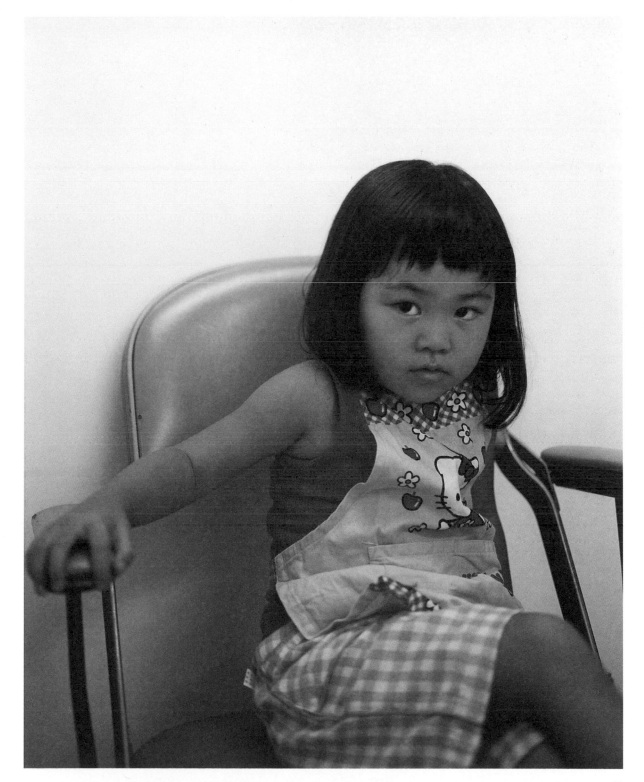

# Takefumi ICHIKAWA

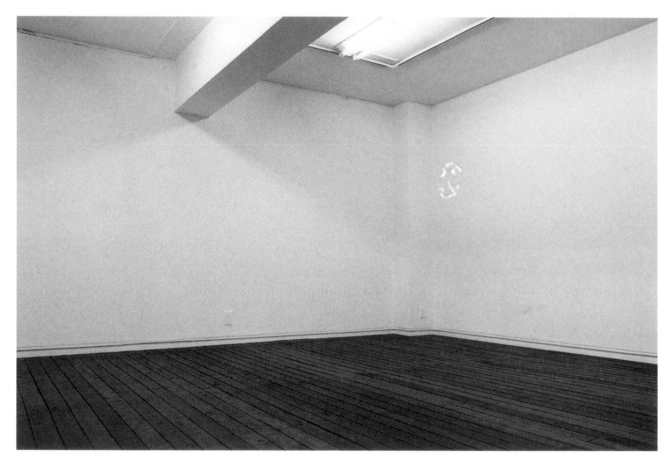

fig. 8
*Fuju O* 1999
particular film, helium gas, air
26 x 21 x 10 cm
Courtesy the artist

Opposite:
fig. 9
*Ken* 1998
particular film, helium gas, air
620 x 150 x 180 cm
Courtesy the artist

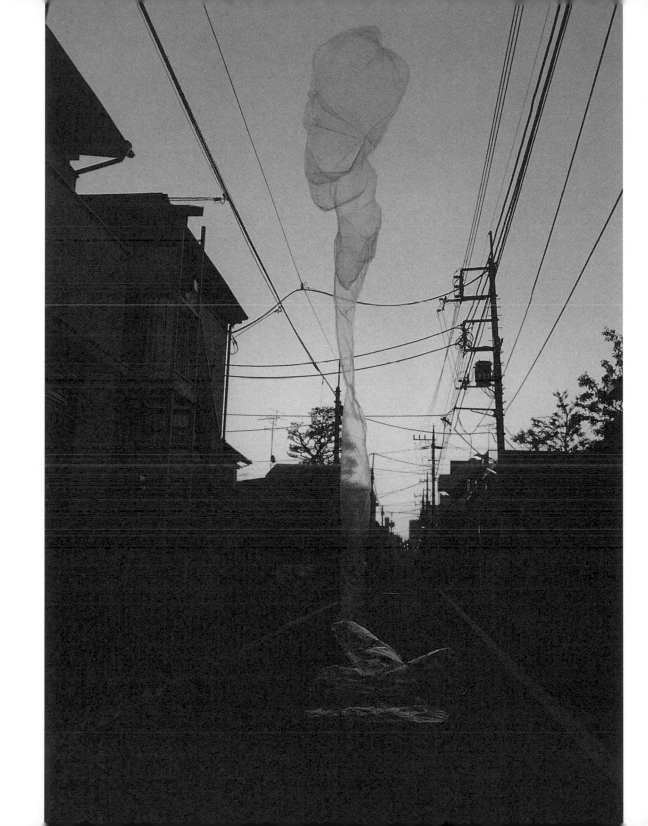

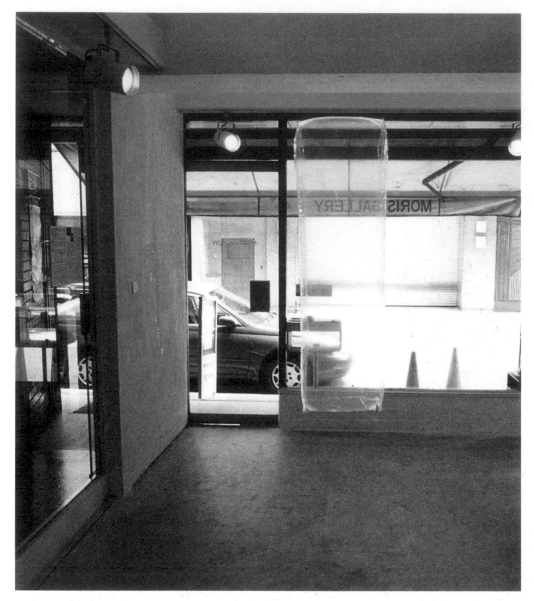

fig. 10
*Fuju 250* 1999
particular film, helium gas, air
170 x 50 x 30 cm
Courtesy the artist

fig. 11
Collaboration with
Gyoko Yoshida
and Ichiro Nakana
*Balloon Tube Project* 1997
particular film, helium
100,000 x 40 x 40 cm
Courtesy the artist

Tomoko  ISODA

cat. 18
*Afterimage* 1998

cat. 26
*Afterimage* 2000

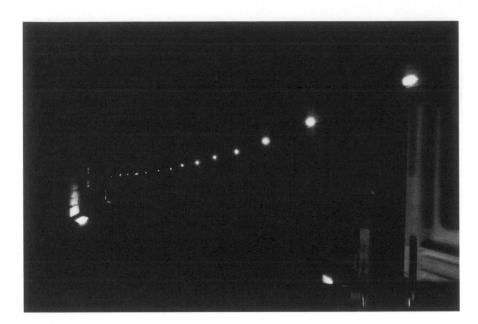

cat. 17
*Afterimage* 1997

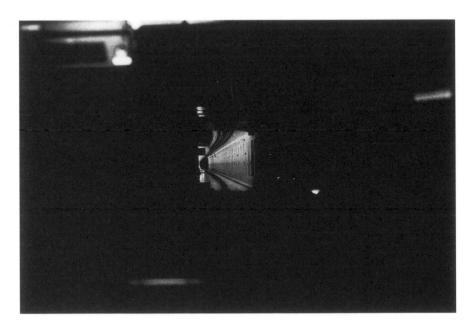

cat. 27
*Afterimage* 2000

cat. 19
*Untitled* 1999

cat. 20
*Untitled* 1999

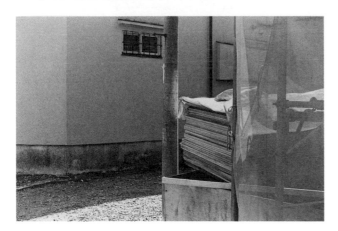

cat. 21
*Untitled* 1999

# Takehisa  KOSUGI

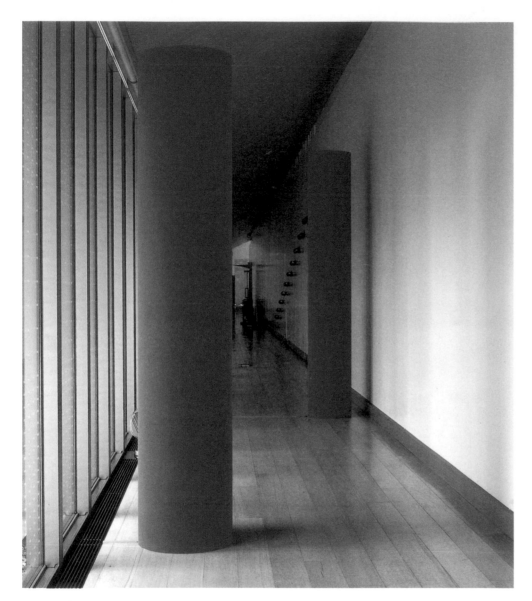

fig. 12
*Fountain* 1999
paper tubes, electronic sound materials
dimensions variable
Utsunomiya Museum of Art
photo: Kiyotoshi Takashima

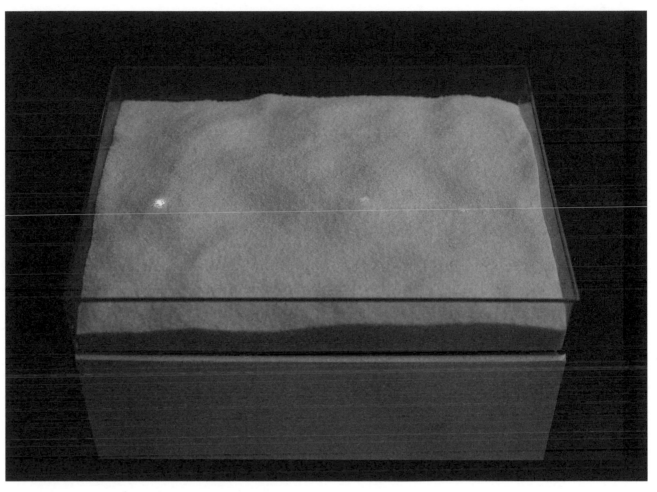

cat. 30
*Interspersion for Light and Sound*  2000

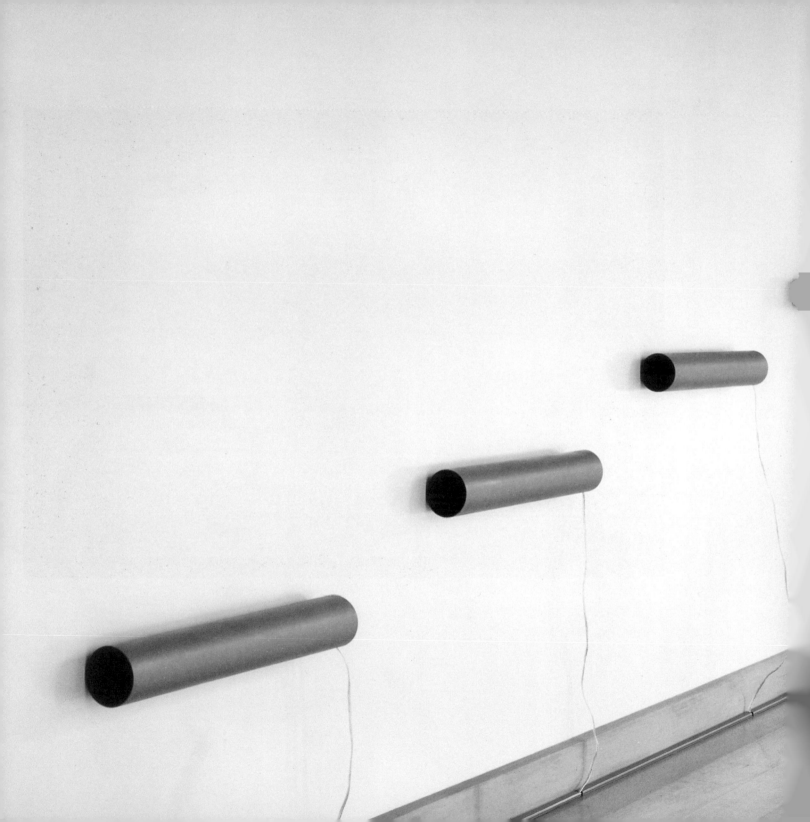

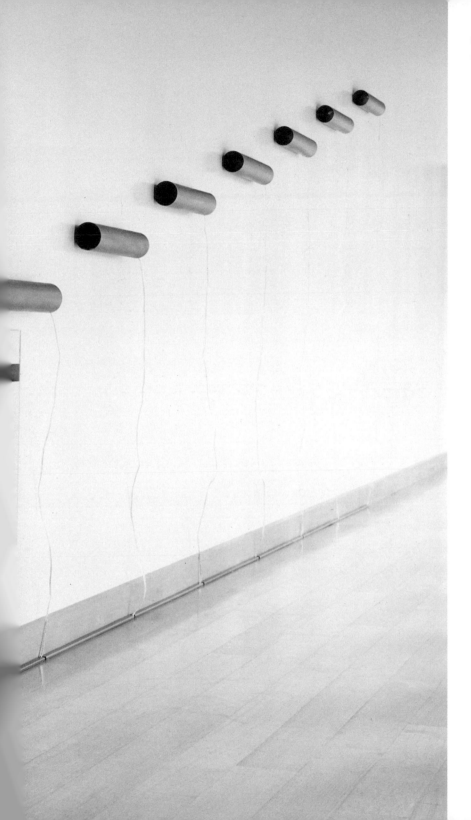

cat. 29
*Stream* 1993

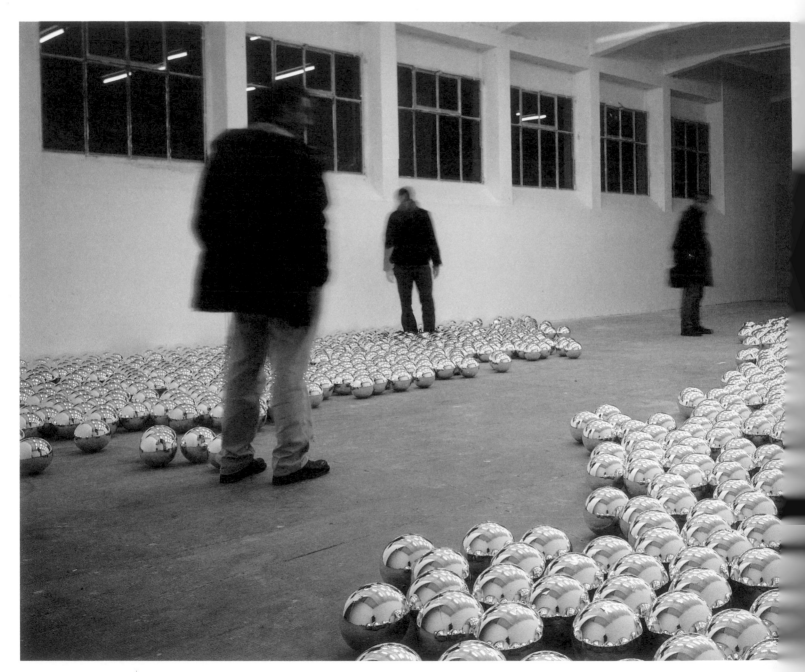

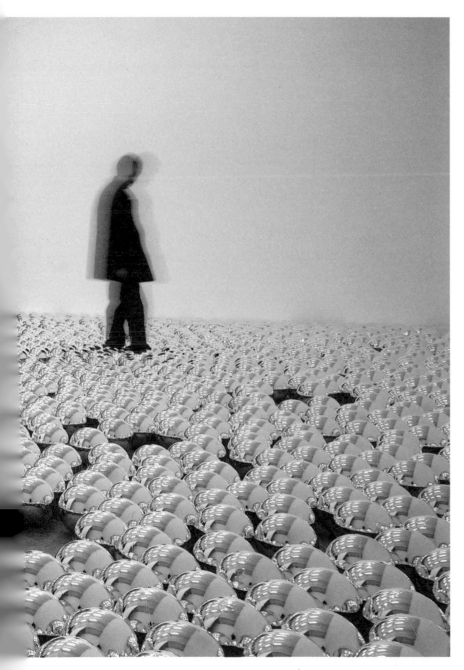

fig. 13
*Narcissus Garden* 2000
silver balls
17 cm diameter each
Collection of the artist
Courtesy of Ota Fine Arts

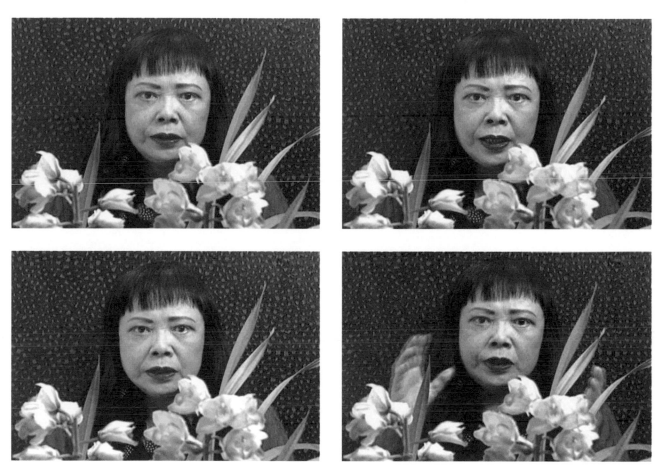

cat. 32 (pp.58-59)
stills from *Song of a Manhattan Suicide Addict* 2001

Tomomi  MAEKAWA

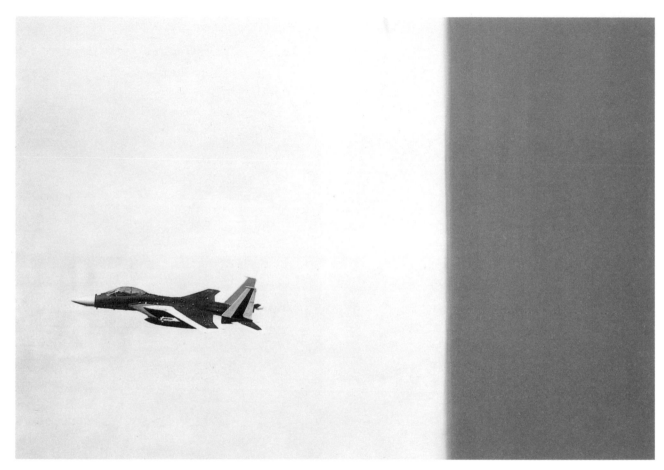

cat. 34
*F-15DJ* 2000

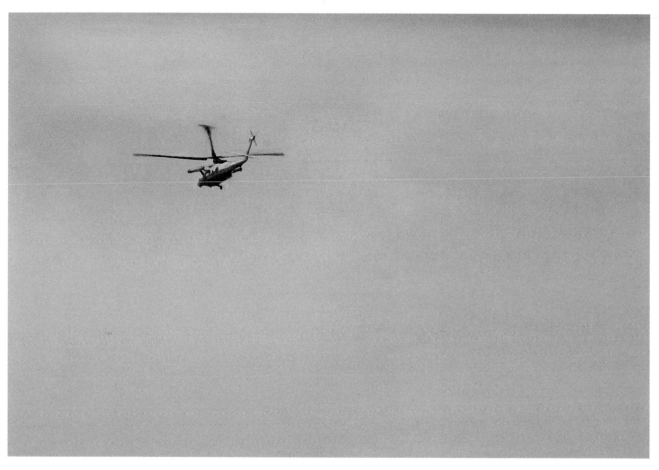

cat. 36
*UH-60J* 2000

cat. 40
*15:30* 2001

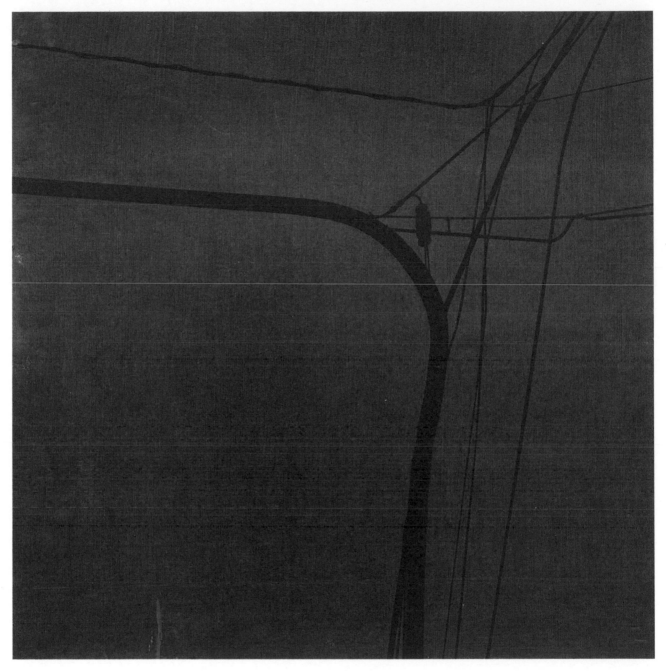

cat. 33
*4:30* 1999

# Tatsuo MIYAJIMA

fig. 14 (pp.64-67)
*Floating Time* 2000
installation with video projection
dimensions variable
Fuji Television Gallery
Photos: Norihiro Ueno

R y u j i  <u>M I Y A M O T O</u>

cat. 43
*Inside Out, Upside Down* 2001

cat. 44
*Inside Out, Upside Down* 2001

Opposite:
cat. 45
*Inside Out, Upside Down* 2001

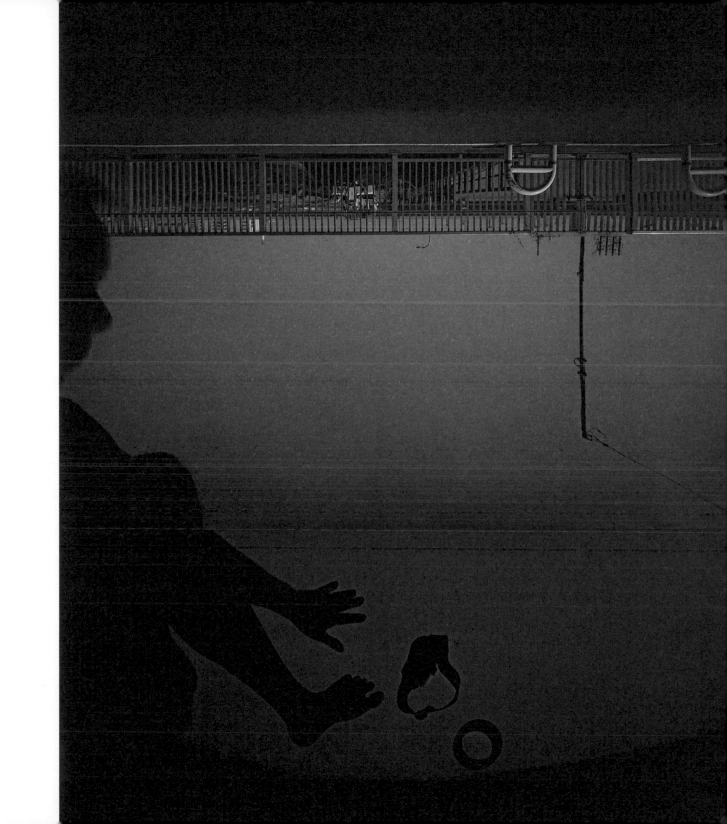

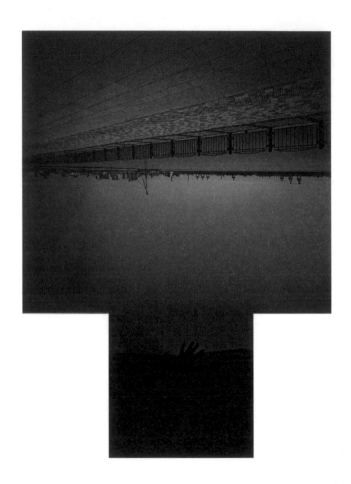

cat. 46
*Inside Out, Upside Down* 2001

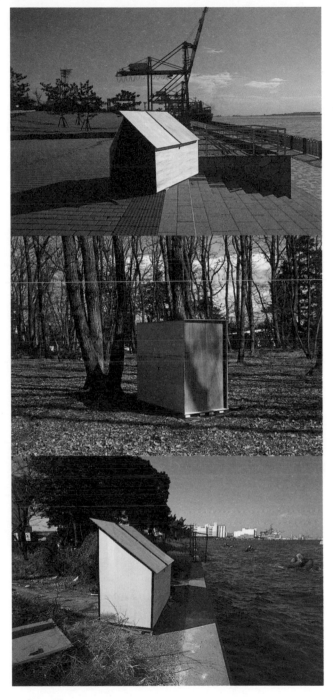

cat. 42
*Pin hole houses* 2000

Yukio **NAKAGAWA**

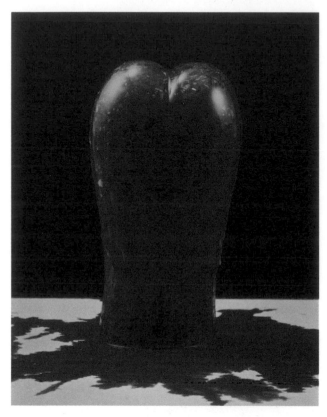

fig. 15
*Flowery Priestess* 1973
900 carnations, self-made glass vase
32 x 80 x 55 cm
Courtesy the artist
Photo: Naomi Maki

fig. 16
*Tulip Seijin* 1993
tulip
dimensions variable

cat. 48
*Flower is the Mystic Mountain* 1989 (remade 2001)

fig. 17
*Uninterrupted Rest C* 1991
glass
dimensions variable
Photo: Yukio Nakagawa

Rika **NOGUCHI**

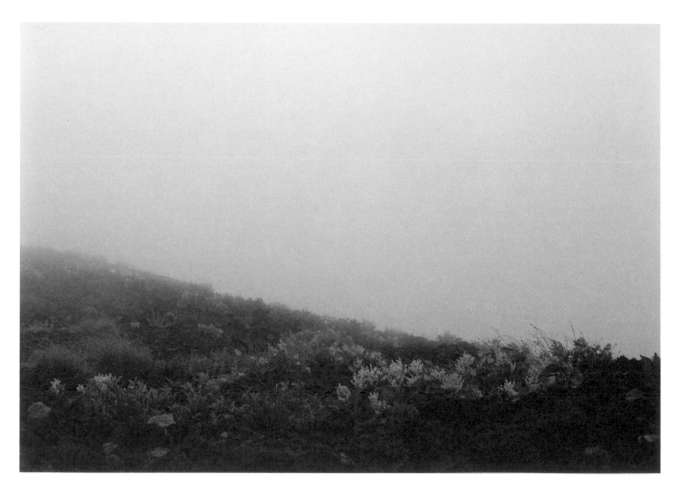

cat. 51
*#14 Untitled* from the series *A Prime* 1999

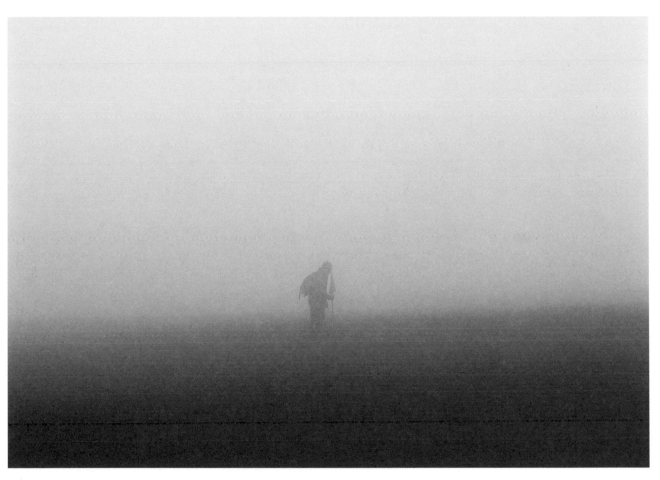

cat. 52
*#15 Untitled* from the series *A Prime* 1999

fig. 18
*Record of Creation* 1998
gelatin silver print
27 x 27 cm
The artist, courtesy Gallery Koyanagi Fine Art

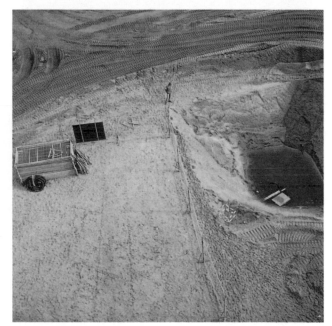

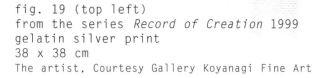

fig. 19 (top left)
from the series *Record of Creation* 1999
gelatin silver print
38 x 38 cm
The artist, Courtesy Gallery Koyanagi Fine Art

fig. 20 (top right, bottom left, above)
from the series *Record of Creation* 1998
gelatin silver print
27 x 27 cm
The artist, Courtesy Gallery Koyanagi Fine Art

# Makoto <u>NOMURA</u>

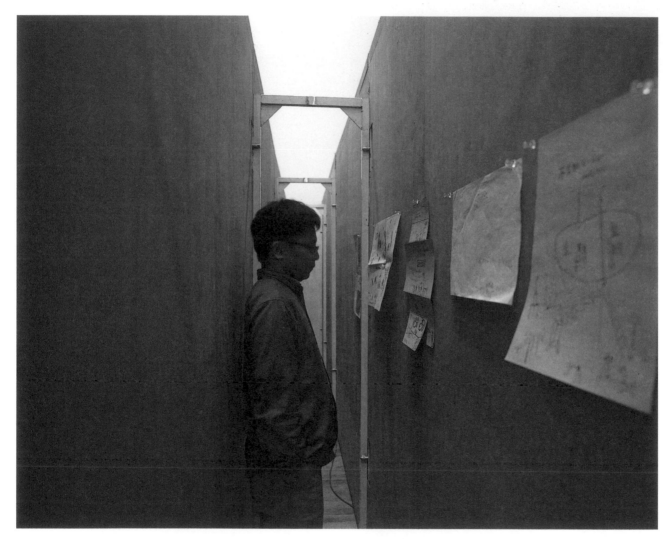

fig. 21
Makoto Nomura and Shimabuku
*Eel* 2001
mixed media
dimensions variable
Photo courtesy Tokyo City Art Gallery
Photo © Masataka Nakano

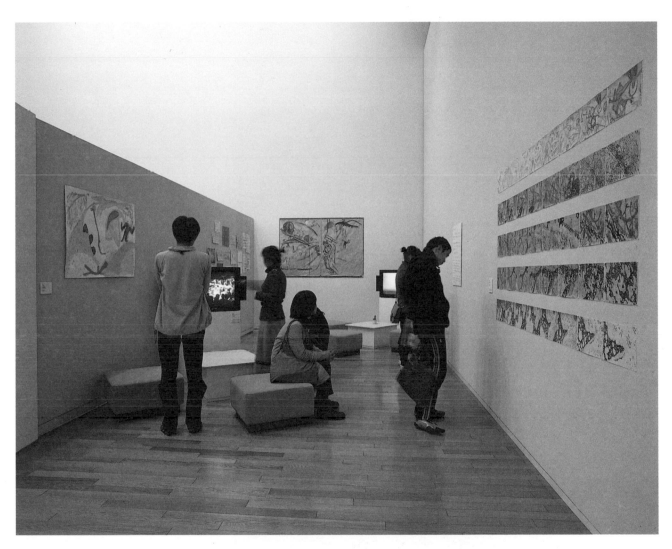

fig. 22
*Shogi composition, etc* 1999
mixed media
dimensions variable
Photo courtesy Tokyo City Art Gallery
Photo © Masataka Nakano

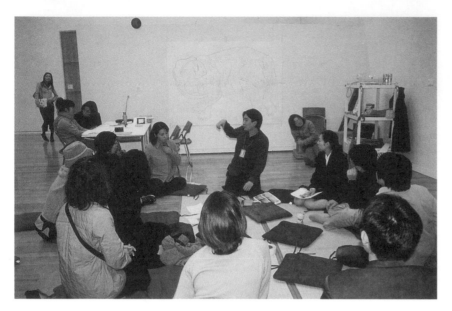

fig. 23
Makoto Nomura and Shimabuku
*Takototanuki Shimabuku Namura Art Foundation* 2000
performance at Tokyo Opera City Art Gallery
photo courtesy Tokyo Opera City Art Gallery

fig. 24
Makoto Nomura with residents of Sakura-en
*Wai Wai Ondo* 1999
collaborative composition with residents of an old people's home

fig. 25
*Hocket for Kobe* 1998
performance at Museum of Ensba, Paris
Photo: Kana Hayashi

fig. 26
*Desi Desi Desi* 1995
performance at Art Tower Mito
Photo: Mikuko Nakamura

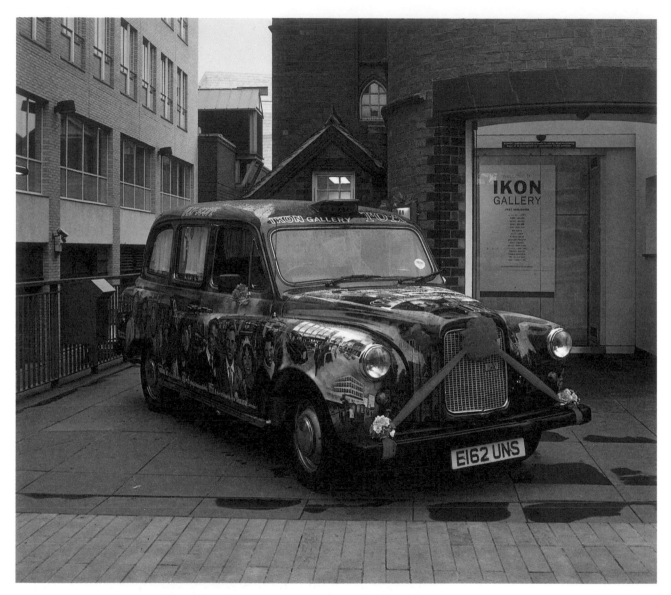

fig. 27 (pp.84-85, 87)
*Shakespeare in Taxi* 2000
Austin black taxi cab with acrylic paint
dimensions variable
Courtesy the artist and Ikon Gallery

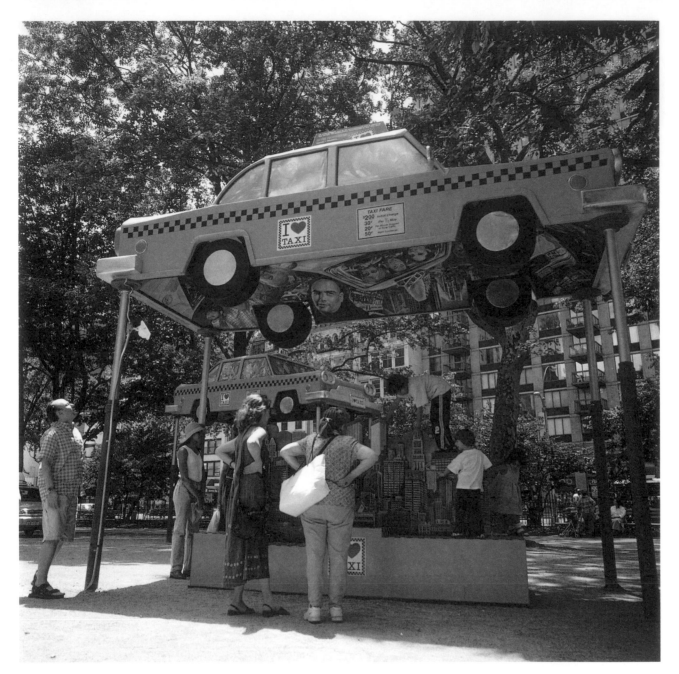

fig. 28
*I ♥ Taxi* 2001
installation
dimensions variable
Courtesy the artist

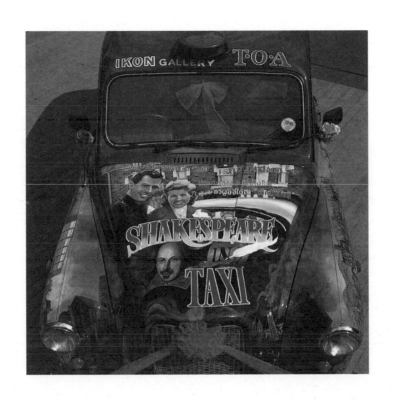

# ROGUES' GALLERY
Yasuhiko **HAMACHI** and Yukihisa **NAKASE**

fig. 29 (pp.88,90)
*Gasoline Music & Cruising* 1995
sound installation
dimensions variable
© Rogues' Gallery 2001
Photo: Kazuo Fukunaga

fig. 30
*Gasoline Music & Cruising* 1995
sound installation
dimensions variable
© Rogues' Gallery 2001
photo courtesy of Spiral/Wacoal Art Center

fig. 31
*Gasoline Music & Cruising* 1993-94
sound installation
dimensions variable
© Rogues' Gallery 2001
Photo: Kazuo Fukunaga

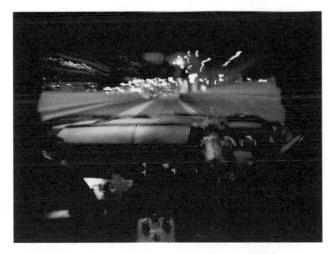

fig. 32
*Gasoline Music & Cruising* 1994
sound installation
dimensions variable
© Rogues' Gallery 2001
Photo: Tadashi Fukumoto

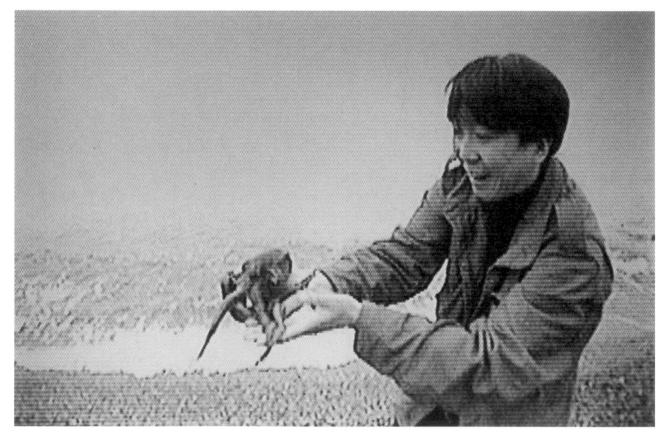

cat. 66 (pp.92-93)
*Then, I decided to give a tour of Tokyo to the Octopus from Akashi* 2000

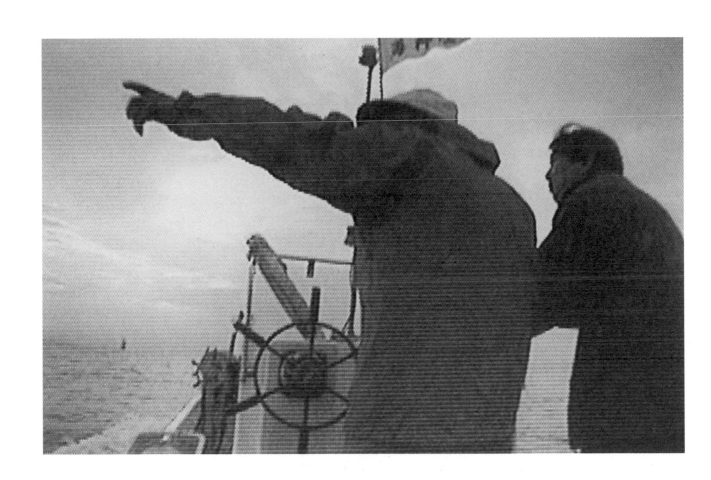

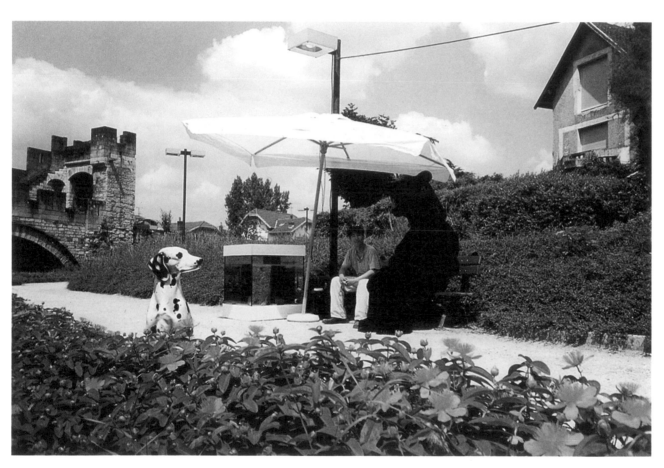

fig. 33
*Octopus waiting for someone with dog and bear* 1999
performance installation
dimensions variable
Courtesy the artist

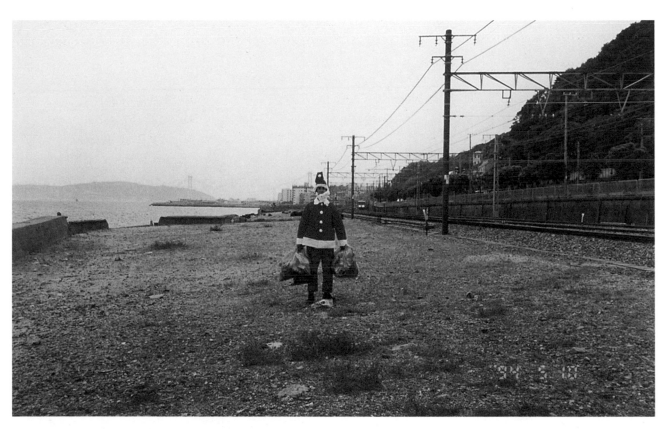

fig. 34
*Christmas in the Southern Hemisphere* 1994
performance - installation
dimensions variable
Courtesy the artist

fig. 35
*Tokyo Installation 2* 1995
paint on wood
dimensions variable
Courtesy the artist

Opposite:
fig. 36
*Crimson Magnolia* 1998
paint on wood
dimensions variable
Courtesy the artist

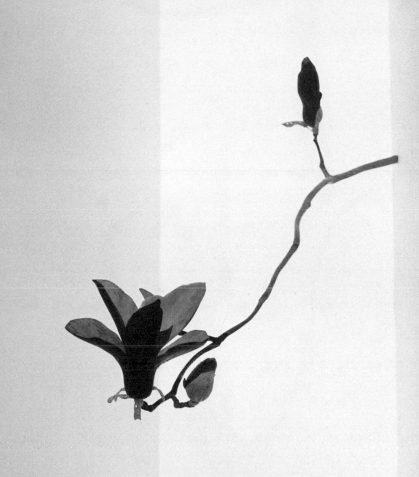

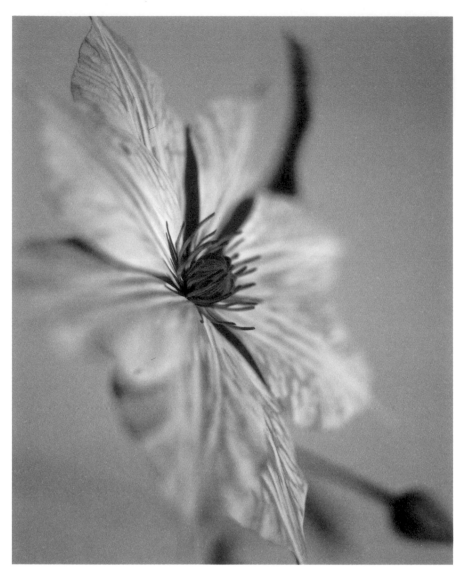

fig. 37
*Wind Mill* 2000
paint on wood
dimensions variable
Courtesy the artist

Opposite:
fig. 38
*Wind Mill* 2000
paint on wood
dimensions variable
Courtesy the artist

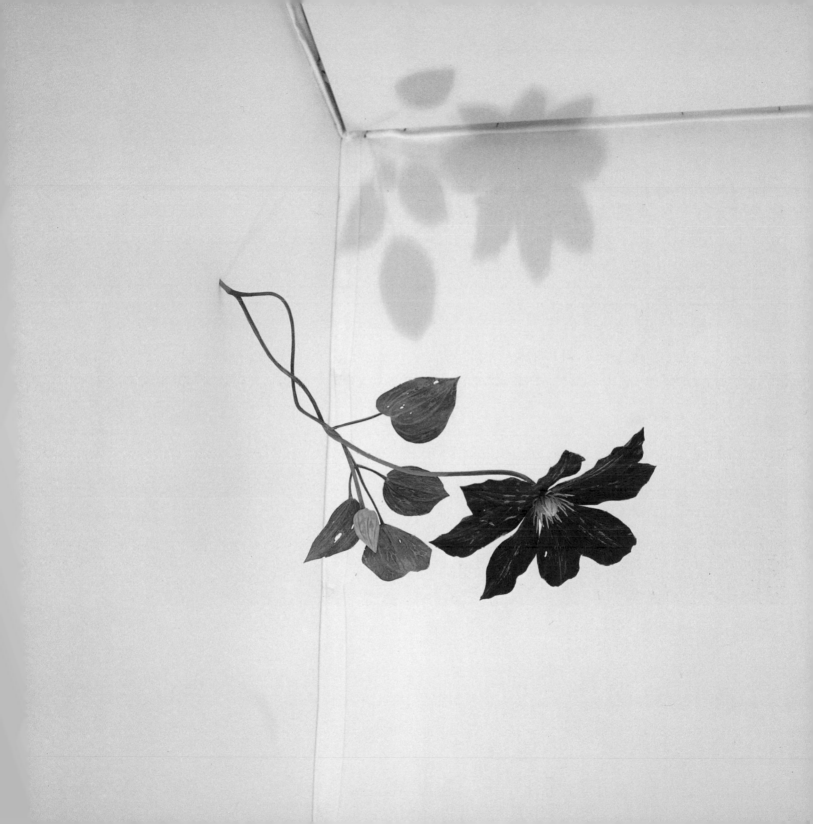

# Hiroshi SUGIMOTO

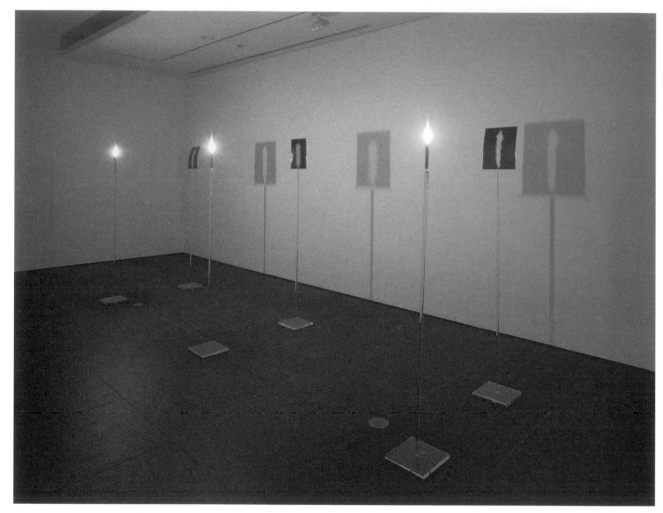

fig. 38a (pp.100-101)
*In Praise of Shadows* 1999
installation
dimensions variable
Collection of the artist
Courtesy Gallery Koyanagi

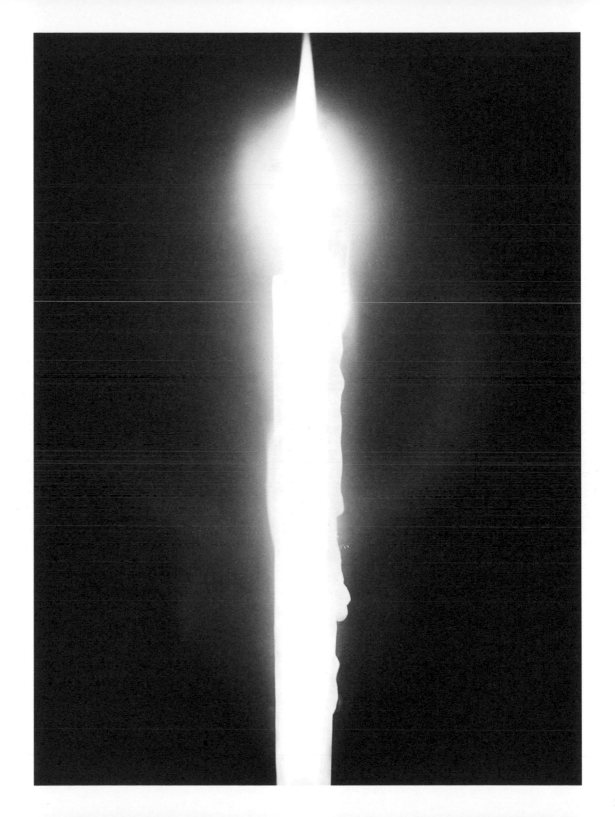

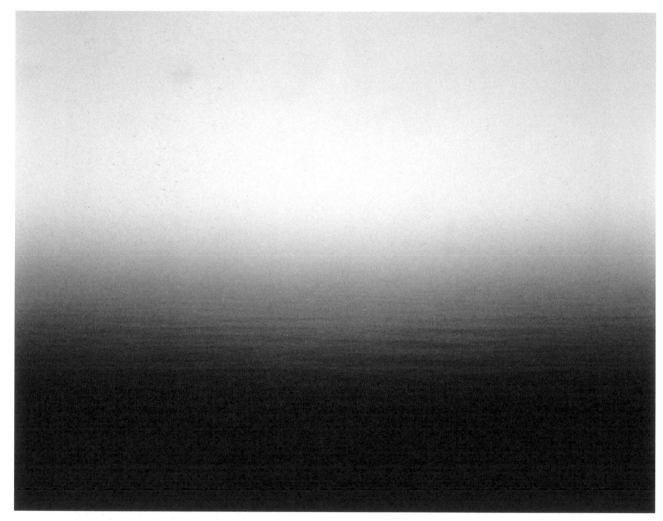

fig. 39
*316 North Atlantic Clifts of Moher* 1989
gelatin silver print
50.8 x 61 cm
The Artist, courtesy Koyanagi Fine Art, Tokyo

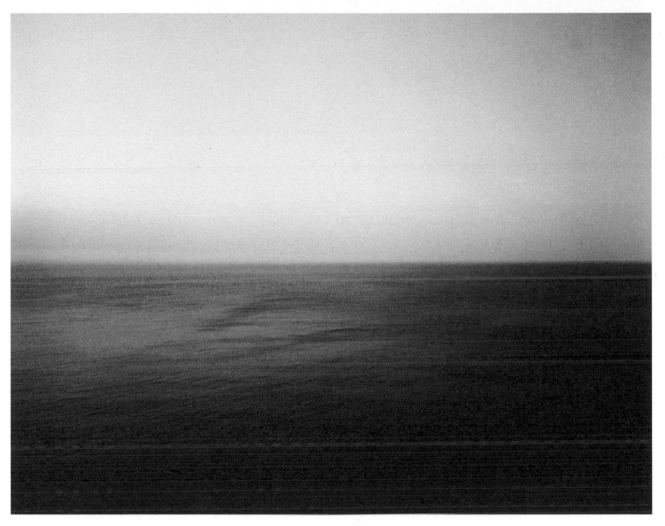

fig. 40
*305 Sea of Japan Hokkaido* 1986
gelatin silver print
50.8 x 61 cm
The Artist, courtesy Koyanagi Fine Art, Tokyo

Tadasu **TAKAMINE** & Masashi **IWASAKI**

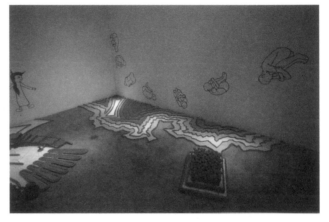

fig. 41
Tadasu Takamine
*A Room With Fingerprint* 1999
mixed media
dimensions variable
Photo courtesy the artist

fig. 42
Tadasu Takamine
*Fuyu-No-Umi (Sea of Winter)* 2000
mixed media
dimensions variable
Photo courtesy the artist

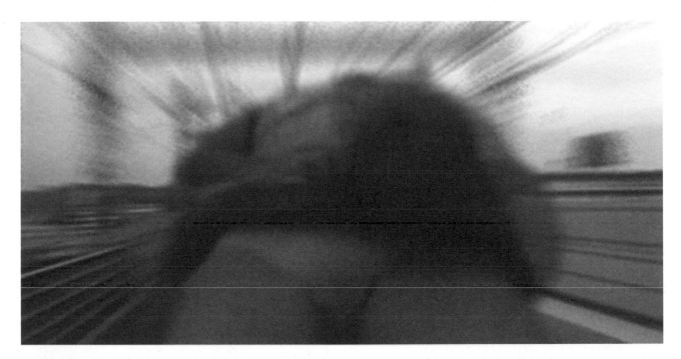

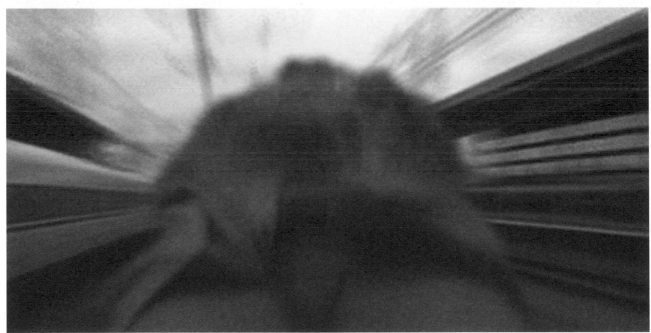

cat. 72
Tadasu Takamine & Masashi Iwasaki
stills from *Inertia* 1998

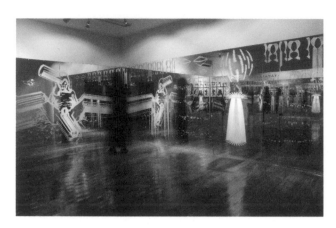

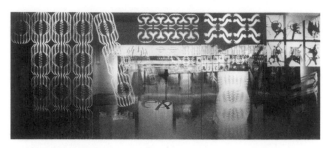

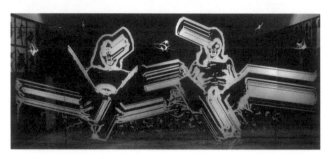

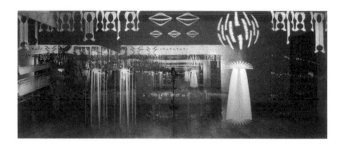

fig. 43
Tadasu Takamine
*Muted Space* 2000
installation with mirror.
patterns drawn by sandblast
500 x 500 cm

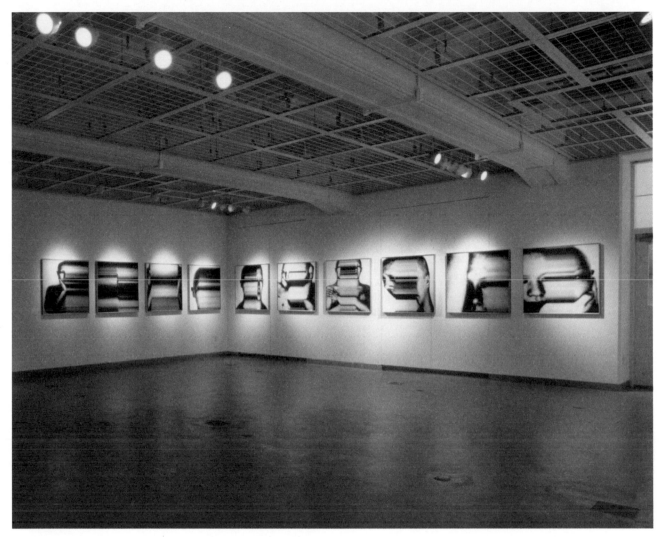

fig. 44
Masashi Iwasaki
*In Silence* 1996
mixed media
90 x 90 cm each
Courtesy the artist

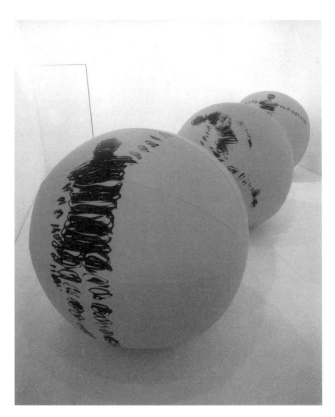

fig. 45
Masashi Iwasaki
*In Sphere* 1998
vinyl jumbo ball, cutting sheet
120 x 120 x 120 cm (each)
Courtesy the artist

fig. 46
Masashi Iwasaki
*Heart & Soul* 1995
computer graphics
dimensions variable
Courtesy the artist

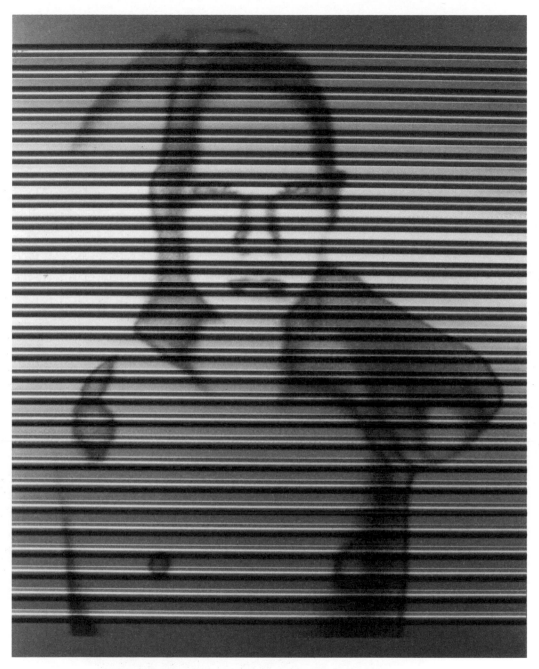

fig. 47
Masashi Iwasaki
*Self Portrait on Metal* 1991
inkjet print on aluminium wavy plate,clear lacquer
150 x 120 cm
Courtesy the artist

Atsuko **TANAKA**

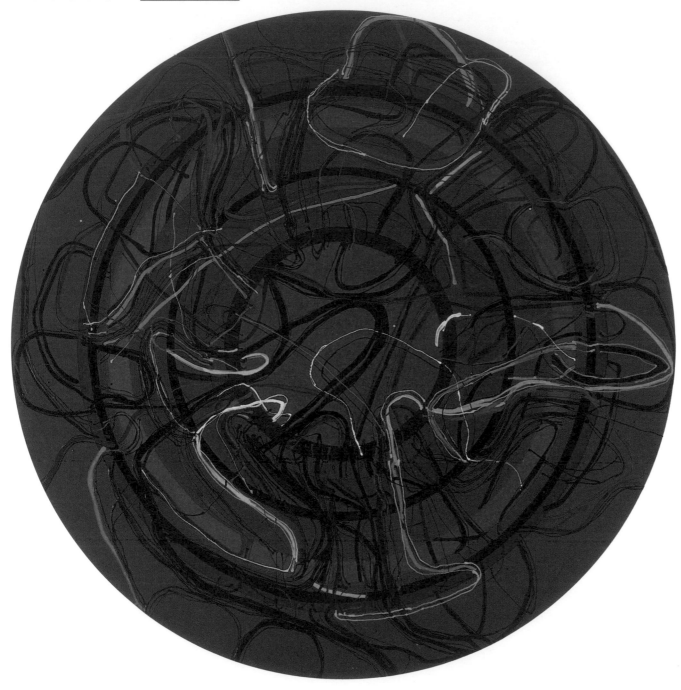

cat. 75
*WORK '91A* 1991

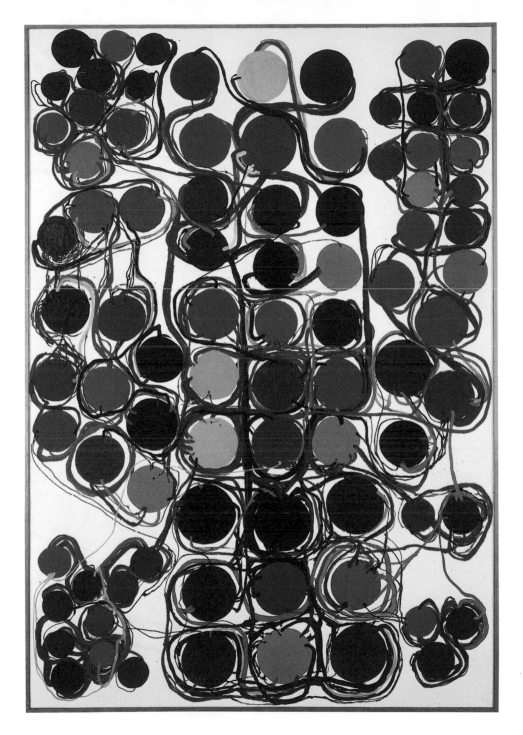

cat. 76
*'991* 1999-2000

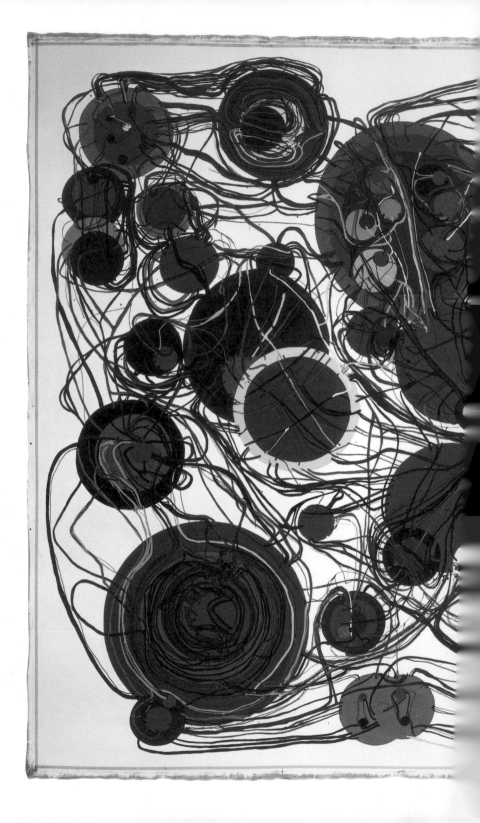

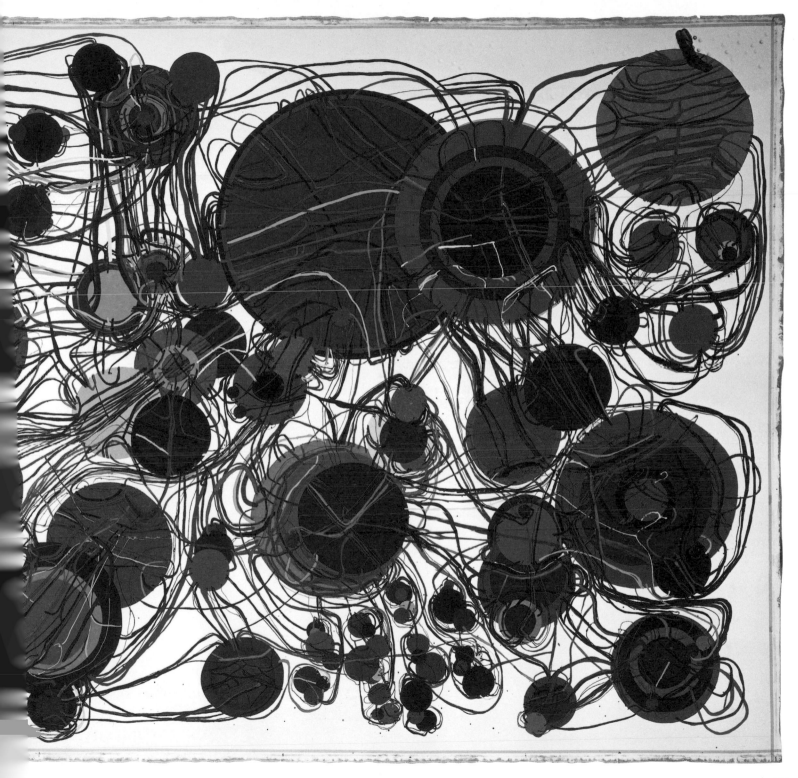

113

Yuji **WATABE**

fig. 48
*Empty Gallery* 2000
pencil drawing on wall
dimensions variable
Westbeth Gallery, Kozuka, Japan
Photo: C.Hasegawa

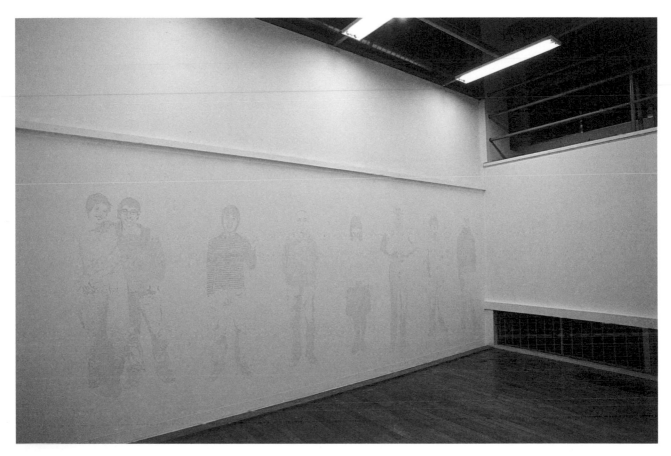

fig. 49
*Open Studio* 2000
pencil drawings on wall
dimensions variable
Courtesy CCA Kitakyusyu

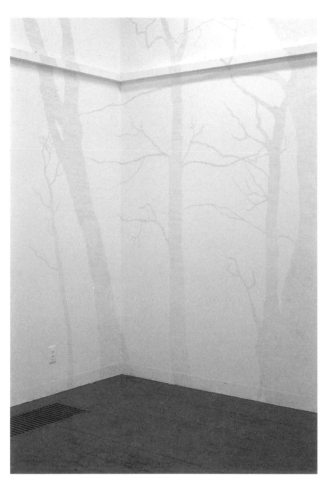 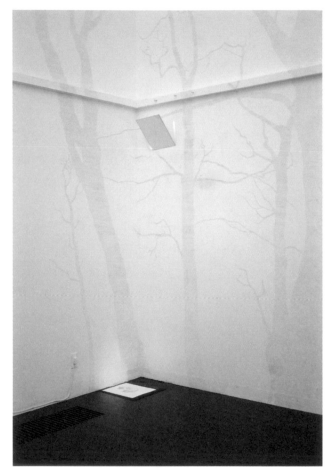

fig. 50
*Forest* 2000
pencil drawing on wall
dimensions variable
Courtesy CCA Kitakyusyu

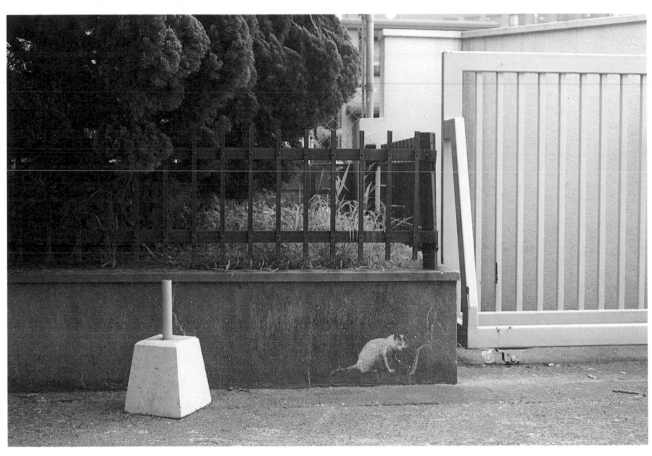

fig. 51
*Lost cat* 2000
drawing on wall
dimensions variable
Courtesy CCA Kitakyusyu

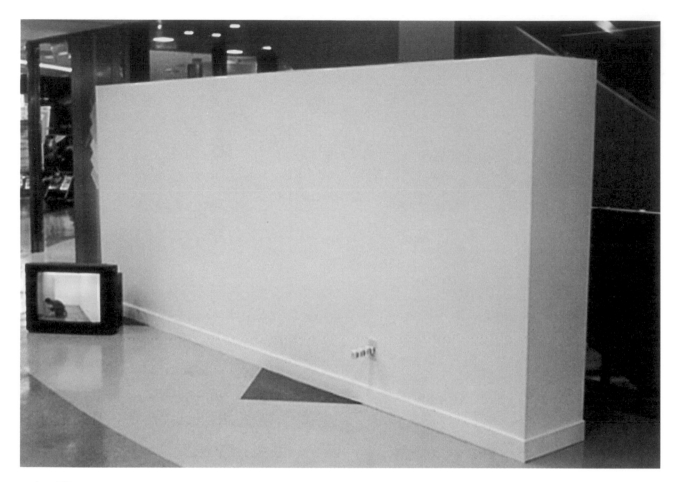

cat. 79
*Drill Man* 1998

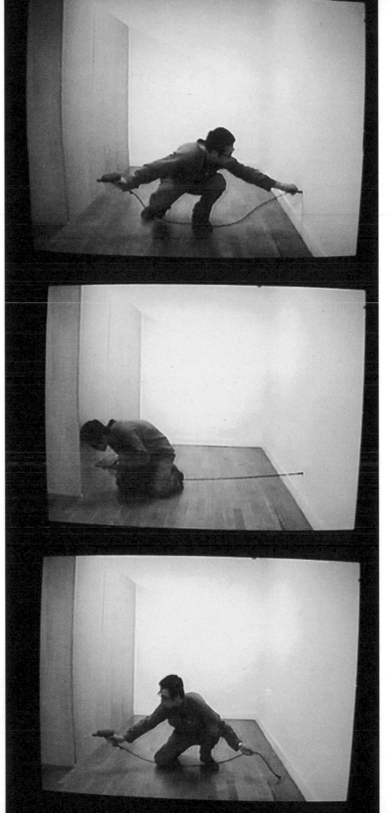

cat. 79
stills from *Drill Man* 1998

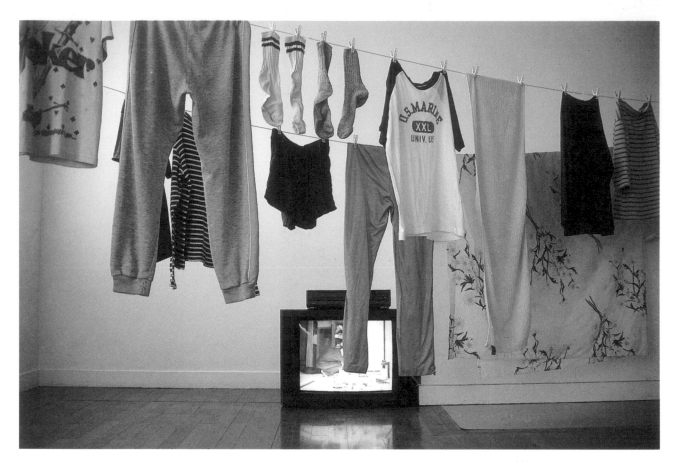

cat. 80
*Clean Up* 1999

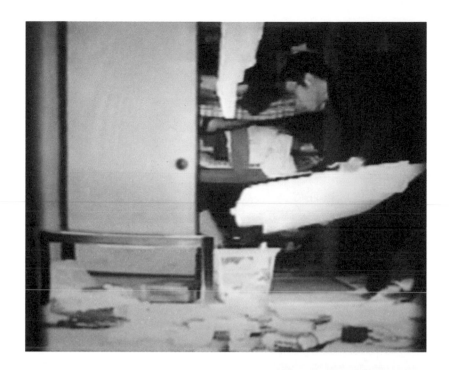

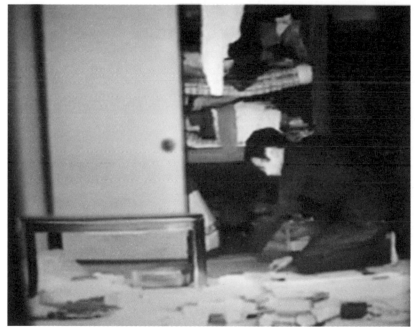

cat. 80
stills from *Clean Up* 1999

# Shigenobu YOSHIDA

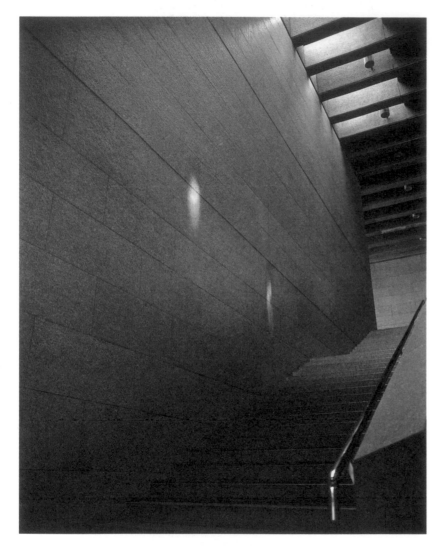

fig. 52
*Iwaki City Art Museum, June 4, 2000* 2000
projection using water and mirrors
dimensions variable
Courtesy the artist

Opposite:
fig. 53
*Capturing rainbows* 1998
workshops and projections using
water, mirrors and sunlight
dimensions variable
Courtesy the artist

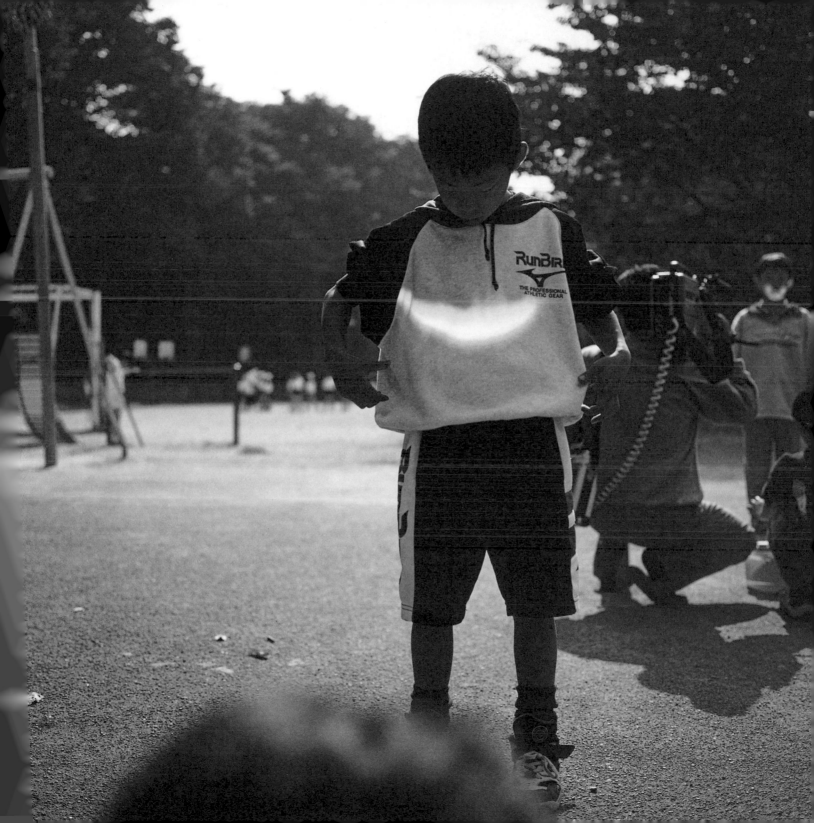

fig. 54
still from *Bordeaux 4:30* 1999
projected video (DVD)
dimensions variable
Courtesy the artist

fig. 55
still from *08.04 No.14 Iwaki* 2000
projected video
dimensions variable
Photo by Koichi Hayakawa

fig. 56
still from *Bordeaux 4:30* 1999
projected video (DVD)
dimensions variable
Courtesy the artist

fig. 57
still from *Bordeaux 4:30* 1999
projected video (DVD)
dimensions variable
Courtesy the artist

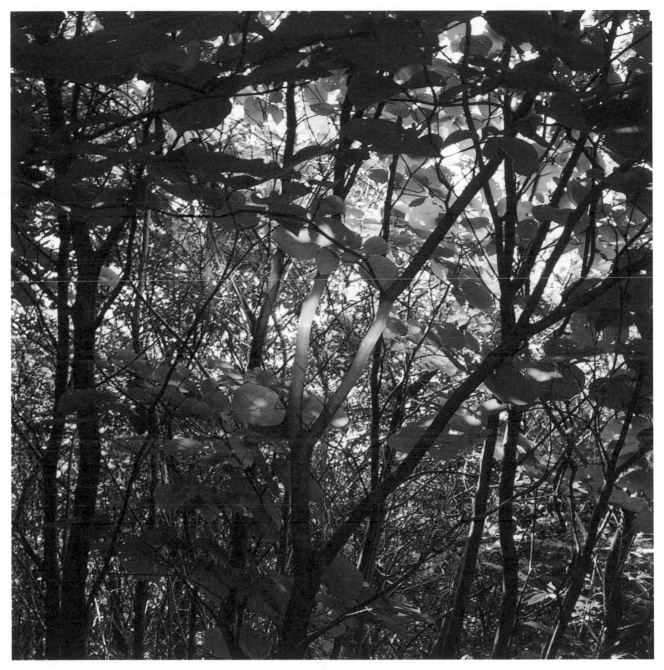

fig. 58
*Iwaki City, September 4, 1998* 1998
projection using water, mirrors and sunlight
dimensions variable
Courtesy the artist

ARTISTS' BIOGRAPHIES

Genpei **AKASEGAWA**

**Born:** 1937, Yokohama
**Lives and works:** Tokyo

**Recent Solo Exhibition:**
2001: *Youth of the Power of the Aged*, Nagoya City Art Museum, Nagoya, Japan

**Selected Recent Group Exhibitions:**
1999: *Out of Actions / Between Performance and the Object*, Museum of Contemporary Art, Tokyo, Japan; Museum of Contemporary Art, Los Angeles, USA
   *Global Conceptualism*, Queens Museum of Art, New York, USA
   *Worthless*, Moderna Galerija, Ljublijana, Slovenia
   *Leica Town in Kyobashi-ku*, Inax Gallery, Tokyo
2000: *Leica Association / Paris Liberation*, Chukyo University C-Square, Nagoya
2001: *Century City*, Tate Modern, London, UK
   *Mega-Wave / Yokohama Triennale 2001*, Pacifico Yokohama, Yokohama, Japan

Nobuyoshi **ARAKI**

**Born:** 1940, Tokyo
**Lives and works:** Tokyo

**Selected Recent Solo Exhibitions:**
1999: *Nobuyoshi Araki*, Scalo Art Space, New York, USA
   *Sentimental Journey, Sentimental Life*, Museum of Contemporary Art, Tokyo, Japan
   *Nobuyoshi Araki*, Rebecca Camhi Gallery, Athens, Greece
   *Polaroids*, Gandy Gallery, Prague, Czech Republic
   *Nobuyoshi Araki*, Contemporary Art Gallery, Vancouver, Canada
2000: *Sentimental Flowers*, Shibuya Mark City, Tokyo
   *My Kyoto 1971-1999*, Isetan Museum, Kyoto, Japan
   *Sentimental Journey*, Centro per l'arte Contemporanea Luigi Pecci, Prato, Italy
   *Erotos*, OP fotogallery, Toronto, Canada
   *Privacy*, Naditt, Tokyo
   *Photo Poche*, La Camera, Tokyo
   *Nobuyoshi Araki*, Galerie Almine Rech, Paris
   *Nobuyoshi Araki*, Damasquine Art Gallery, Brussels, Belgium
   *Photography of the End of the Century*, Institut franco-japonai, Tokyo
   *Fassa Love*, Galerie Les Trois Agneaux, France
2001: *Kaei*, Gallery Art Graph, Tokyo
   *Shikijyo kyo*, Taka Ishii Gallery, Tokyo
   *Uen Yanaka Biyori*, Gallery J2, Tokyo
   *Shosetsu Seoul*, Spiral Hall, Tokyo
   *Tokyo Still Life*, Ikon Gallery, Birmingham, UK

**Selected Recent Group Exhibitions:**
2000: *Bourgeois Hero*, Galleria Civica Modena, Modena, Italy
   *Copenhagen Festival*, Copenhagen, Denmark
   *Gendai: Japanese Contemporary Art*, Center for Contemporary Art, Ujadowski Castle, Warsaw, Poland

2001: *Racolta della Fotografia Contemporanea*, Galleria Civica Modena, Modena
*Ganjin and photographers from the world*, Matsuzakaya Gallery, Tokyo
*See, Take a picture, Express*, Setagaya Museum, Tokyo
*Promiscuous Flowers - Robert Mapplethorpe & Nobuyoshi Araki*, Niitsu City Museum, Niigata, Japan; Odakyu Museum, Shinjuku, Japan
*Strategies - photography of the nineties*, Kunsthalle, Kiel, Germany; Museo d'Arte Moderna, Bolzano, Italy; Rupertinum, Salzburg, Austria
*The body and the sin*, Valencia Biennale, Valencia, Spain

# Yukio **FUJIMOTO**

**Born:** 1950, Nagoya
**Lives and works:** Osaka

**Recent Solo Exhibitions:**
1999: *Audio Picnic at the Museum 3/10*, Otani Memorial Art Museum, Nishinomiya City, Japan
2000: *AUDIO/VISUAL*, Gallery Caption, Gifu, Japan
*Audio Picnic at the Museum 4/10*, Otani Memorial Art Museum, Nishinomiya City
2001: *PHILOSOPHICAL TOYS*, SAI Gallery, Osaka, Japan

**Recent Group Exhibitions:**
1999: *A Sense of Reality*, Utsunomiya Museum of Art, Tochigi, Japan
*Art of the Senses*, Kunsthaus, Hamburg, Germany
2000: *Art and Society: Earthquake*, Taro Okamoto Museum of Art, Kawasaki, Japan
*Art of the Senses*, CASO, Osaka; Garden Korakuen, Okayama, Japan
2001: *49th Venice Biennale*, Giardini di Castello, Venice, Italy

# Takashi **HOMMA**

**Born:** 1962, Tokyo
**Lives and works:** Tokyo

**Recent Solo Exhibitions:**
1999: *Homma Takashi Exhibition 99*, The deep, Tokyo, Japan
*Tokyo Suburbia*, Parco Gallery, Nagoya, Japan
2000: *Tokyo Suburbia*, Fotomuseam, Winterthur, Switzerland
*Aero Photo*, Gallery 260, Tokyo
*Tokyo Willie*, Taka Ishii Gallery, Tokyo

**Recent Group Exhibitions:**
1999: *Kimura Ihei Memorial Photography Award 1975-1999*, Kawasaki City Museum, Kawasaki,Japan
*Tokyo 60-90 - 17 Photographers*, Tokyo Metropolitan Museum of Photography, Tokyo
2000: *In the Age of Cold Burn*, Museum of Contemporary Art, Tokyo
*Presumed Innocents*, Cape Musée, Bordeaux, France
*Elysian Field*, Centre Pompidou, Paris, France

## Takefumi ICHIKAWA

**Born:** 1971, Nagoya
**Lives and works:** Tokyo

**Recent Solo Exhibitions:**
2000:  Moris Gallery, Tokyo, Japan
       Gallery 21+Yo, Tokyo
2001:  Gallery 21+Yo, Tokyo
       Nagakute Cultural Center, Aichi, Japan

**Recent Group Exhibitions:**
1999:  *Jiman-Manzoku-IV*, Gallery 21+Yo, Tokyo
       *The 4th Contest for the Best Contemporary Art Work 2000*, Soko Gallery, Tokyo; Moris
       Gallery, Tokyo
2000:  *Jiman-Manzoku-V*, Gallery 21+Yo, Tokyo
2001:  *Bit/White Steam*, Tokyo Gallery, Tokyo
       *Small Art Works 2001*, Skydoor Art Place, Tokyo

**Recent Projects:**
2001:  Balloon Tube Project in Nagakute, Nagakute Cultural Center, Aichi

**Recent Performances:**
2000:  *Ongaku-Ensou*, Tokyo Gallery, Tokyo
2001:  *Ongaku-kai*, Gallery 21+Yo, Tokyo

## Tomoko ISODA

**Born:** 1976, Tochigi
**Lives and works:** Tochigi

**Recent Solo Exhibition:**
1999:  *Afterimage*, TOKI Art Space, Tokyo

**Recent Group Exhibition:**
2000:  *Contemporary Photographer II Anti-Memory*, Yokohama Museum of Art, Yokohama, Japan

## Masashi IWASAKI

**Born:** 1966, Osaka
**Lives and works:** Kyoto

**Recent Solo Exhibitions:**
1999:  *Quiet Quadrangle*, Voice Gallery, Kyoto, Japan
2000:  *Fragmentation*, Voice Gallery, Kyoto

**Recent Group Exhibition:**
2000:  *The flower of 100 blooms all over*, Gallery Raku, Kyoto

Takehisa **KOSUGI**

**Born:** 1938, Tokyo
**Lives and works:** Osaka and New York

Recent Solo Exhibitions:
2000:   *Sound Picture*, Gallery Toile, Fukuoka, Japan
2001:   *Dial Music*, Gallery 360°, Tokyo, Japan

Recent Group Exhibitions:
1999:   *Koisuru Shintai*, Utsunomiya Museum of Art, Utsunomiya, Japan
2000:   *Visual Sound*, Mattress Factory, Pittsburg, USA
2001:   *Experiments in Music - USA / JAPAN*, Aichi Arts Center, Nagoya, Japan

Yayoi **KUSAMA**

**Born:** 1929, Matsumoto
**Lives and works:** Tokyo

Selected Recent Solo Exhibitions:
1999:   Museum of Contemporary Art, Tokyo, Japan
        Ota Fine Arts, Tokyo
        MOMA Contemporary, Fukuoka, Japan
        Crown Art Center, Taipei, Taiwan
2000:   Serpentine Gallery, London, UK
        Piece Unique, Paris, France
        Ota Fine Arts, Tokyo
        Le Consortium, Dijon, France
2001:   Maison de la Culture du Japon, Paris
        Kunsthallen Brandts Klaedefabrik, Odense, Denmark
        Ota Fine Arts, Tokyo
        Les Abattoirs, Toulouse, France
        Piece Unique, Paris, France

Selected Recent Group Exhibitions:
1999:   *Out of Action 1949-1979. Between Performance and Object*, Museum of Contemporary Art, Tokyo
        *The American Century: Art and Culture 1900-2000*, Whitney Museum of American Art, New York, USA
        *Contemporary Classicism*, Neuberger Musuem of Art, Purchase, USA
        *Spiral TV*, Spiral Garden, Tokyo
        *Visions of the Body: Fashion or Invisible Corset*, The National Museum of Modern Art, Kyoto, Japan
2000:   *Works on Paper*, Ota Fine Arts, Tokyo
        *Winter Day*, Gallery HAM, Nagoya, Japan
        *Biennale of Sydney 2000*, Sydney, Australia
        *Japanese Art in the 20th Century*, Museum of Contemporary Art, Tokyo
        *Hyper Mental*, Kunsthaus, Zurich, Switzerland
        *Century City*, Tate Modern, London
        *Les années Pop*, Centre George Pomipidou, Paris
        *Collaborations with Parkett 1984 to Now*, The Museum of Modern Art, New York
        *Works on Paper from Acconci to Zittel*, Victoria Miro Gallery, London

## Tomomi  MAEKAWA

**Born:** 1973, Nagoya
**Lives and works:** Sagamihara

**Recent Solo Exhibitions:**
2000:   Ota Fine Arts, Tokyo, Japan
2001:   Ota Fine Arts, Tokyo

**Recent Group Exhibitions:**
1999:   *Koji Sekimoto + Tomomi Maekawa*, Ota Fine Arts, Tokyo
2001:   *VOCA 2001*, Ueno Royal Museum of Art, Tokyo
        *Line and Space/Landscape*, Fukui City Art Museum, Fukui, Japan

## Tatsuo  MIYAJIMA

**Born:** 1957, Tokyo
**Lives and works:** Ibaraki

**Recent Solo Exhibitions:**
1999:   Studio Casoli, Milan, Italy
        Galerie Buchmann, Cologne, Germany
        *Floating Time*, Fuji Television Gallery, Tokyo, Japan
        *MEGA DEATH: shout! shout! count!*, Tokyo Opera City Art Gallery, Tokyo
2000:   *Monism / Dualism*, SCAI The Bathhouse, Tokyo
        *Counter pieces*, Galerie der Stadt Stuttgart, Stuttgart, Germany
        *Floating Time*, Gallery Stefan Andersson, Umea, Sweden
        *Counter Ground*, Dallas Museum of Art, Dallas, USA
        *Totality of Life*, Luhring Augustine Gallery, New York, USA
2001:   Galerie Buchmann, Cologne

**Selected Recent Group Exhibitions:**
1999:   *Prime*, Dundee Contemporary Arts, Scotland
        *Melbourne International Biennale*, Melbourne, Australia
        *48a La Biennale di Venezia: Whither the Arts?*, Venice, Italy
        *KRONOS&KAIROS*, Museum Fridericianum, Kassel, Germany
        *The 3rd Asia-Pacific Triennale*, Queensland Art Gallery, Sydney, Australia
        *Kunst-Welten im Dialog*, Museum Ludwig Köln, Cologne
2000:   *Time*, NOB Gallery, Okazaki, Japan
        *Das fünfte Element – Gelt oder Kunst*, Kunsthalle Düsseldorf, Düsseldorf, Germany
        *Piece of Universe, Piece of Time*, Nigata City Museum, Nigata, Japan
        *Game Over*, WATARI-UM, Tokyo
        *Orbis Terraru*, Museum Plantin, Antwerpen, Belgium
        *Gendai – Japanese Contemporary Art*, Center for Contemporary Art, Ujazdowski Castle, Warsaw, Poland
        *Shanghai Biennale*, Shanghai Art Museum, Shanghai, China
2001:   *Black Box*, Kunstmuseum, Bern, Switzerland
        *The Standard*, Naoshima Contemporary Art Museum, Kagawa, Japan

# Ryuji  MIYAMOTO

**Born:** 1947, Tokyo
**Lives and works:** Tokyo

**Recent Solo Exhibitions:**
1999:   *Urban Apocalypse*, Kunstlerhaus Bethanien, Berlin, Germany
        *Ryuji Miyamoto*, The Box Gallery, Torino, Italy
2000:   *Pinhole House*, Akiyama Gallery, Tokyo, Japan
        *Urban Apocalypse*, The Brno House of Art, Brno, Czech Republic
        *Museum Island*, Neues Museum, Berlin
2001:   *Up-side-down In-side-out*, Akiyama Gallery, Tokyo
        *New York - Vancouver 1975-76*, Place M, Tokyo

**Recent Group Exhibitions:**
1999:   *Cities on the Move*, Hayward Gallery, London, UK
        *Fotofestival Naarden*, Naarden, The Netherlands
        *Attack!*, Holland Festival, Amsterdam, The Netherlands
        *Modena per la Fotografia 1999*, Galleria Civica Modena, Modena, Italy
        *5.Internationale Footage Herten*, Herten, Germany
        *La Mort*, Gilles Peyroulet & Cie Gallery, Paris, France
2000:   Tanlay Art Fair, Centre d'Art de Tanlay, Tanlay, France
        *Architecture of the City*, Neues Museum, Nürnberg, Germany
        Art forum Berlin, Messe Berlin, Berlin
        *Genealogy of Contemporary Photography*, Nikon Salon, Tokyo
2001:   *Wenn Berlin Biarritz ware...*, Folkwang Museum, Essen, Germany

# Yukio  NAKAGAWA

**Born:** 1918, Marugame City
**Lives and works:** Tokyo

**Recent Solo Exhibition:**
2000:   Shiseido Art Space, Tokyo, Japan

**Recent Group Exhibition:**
1999:   *More than meets the eye*, Deichtorhallen, Hamburg, Germany

# Rika  NOGUCHI

**Born:** 1971, Saitama
**Lives and works:** Yokohama

**Recent Solo Exhibitions:**
1999:   Gallery Koyanagi, Tokyo, Japan
        *Noguchi Rika*, Gallery Koyanagi, Tokyo
2001:   *Did he reach the moon?*, Parco Gallery, Tokyo; *D'AMELIO TERRAS*, New York, USA
        *a feeling of something happening*, Marugame Genichiro-Inokuma Museum of Contemporary Art,
        Marugame, Japan

**Recent Group Exhibitions:**
1999:    *Private Room*, Contemporary Art Center, Art Tower-Mito, Mito, Japan
         *Neu land*, Kunstverein Wiesbaden, Wiesbaden, Germany
2000:    *Sensitive*, Printemps de Cahors, Cahors, France
         *Japan medium light*, montevideo, Amsterdam, The Netherlands
2001:    *Standard*, Naoshima Contemporary Art Museum, Naoshima, Japan

# M a k o t o   **N O M U R A**

**Born:** 1968, Nagoya
**Lives and works:** Tokyo

**Selected Recent Performances:**
1999:    *P-blot 3 years Anniversary Concert*, Monnaka Tenjo Hall, Tokyo, Japan
         *Tsukuru, Oto, Odoru (Create, Sound, Dance)*, atelier GEKKEN, Kyoto, Japan
2000:    *Concerts by Young Musicians of Traditional Japanese Musical Instruments*,
         The Mini Theater, Aichi Prefectural Art Center, Aichi, Japan
         *The 6th Juksan International Arts Festival*, Juksan, Korea
         *Nomura Makoto and Shogi Composition Festival*, Nadia Park, Nagoya, Japan

**Selected Recent Projects:**
1999:    *Tsun, Koitsume (shou, koto, sangen, futozao, and uchimono / commission work)*, Sumida
         Triphony, Tokyo / Nagoya / Shizuoka / Kobe (CD), Japan
         *F and I had a quarrel because of trifles (electronic organ)*, The Maison de la Culture du
         Japon à Paris, Paris, France
2000:    *Away from Home with Eggs (piano / commission work)*, Moscow, Russia / Amsterdam, The
         Netherlands / Den Haag, The Netherlands / Utrecht, The Netherlands / Tokyo (CD)
         *Cicada (Javanese gamelan / commission work)*, Lobby, the Head Office, Asahi Breweries Ltd.,
         Tokyo / Nagakute Cultural Center, Aichi / Kyoto City University of Arts, Kyoto
2001:    *Next Dance Festival*, Park Tower Hall, Tokyo
         *Nomura Makoto and Shogi Composition Festival*, Asuke Satoyama Youth Hostel, Aichi

**Other Recent Activities:**
1999:    Participant Symposium, *Nomura Makoto Art Workshop: The Report of Composition with the Aged*,
         Conference Room, Tokyo Toyota Co. Ltd, Tokyo
2000:    PACJAP (computer project by musician in Marseilles and Tokyo), ICC Inter Communication
         Center, Tokyo
         Workshop, *The Challenge of Body Orchestra*, Special Exhibition, *Theater at the Museum: The
         Expressive Body*, National Museum of Ethnology, Osaka, Japan
         Music, *Children Sanbasoh* (opera), Joruri Theater, Osaka
2001:    *Encounter*, Tokyo Opera City Art Gallery, Tokyo

# Navin  RAWANCHAIKUL

**Born:** 1971, Chiang Mai, Thailand
**Lives and works:** Fukuoka, Japan, and Chiang Mai

**Selected Recent Solo Exhibitions / Projects:**
1999: *Asking for Nothingness*, Satani Gallery, Tokyo, Japan
2000: *Taximan, About Studio / About Café*, Bangkok, Thailand
       *Fly with me to Another World*, Le Consortium, Dijon, France
2001: *I ❤ Taxi*, a Public Art Fund project in collaboration with P.S.1 Contemporary Art Center,
       New York, USA
       *Chateau Scoterus*, A project with Eurovespa 2001, Fourchambault, France
       *Navin Rawanchaikul (with Adel Abdessemed)*, Galleria Laura Pecci, Milan, Italy

**Selected Recent Group Exhibitions:**
1999: *I Love Art 5*, Watari Museum of Contemporary Art, Tokyo
       *Cities on the Move 4 (Midnight Sun)*, Art Space One Percent, Copenhagen, Denmark
       *Game Over*, Watari Museum of Contemporary Art, Tokyo
       *Zeit Wenden*, Kunst Museum, Bonn, Germany; Museum Moderner Kunst Stiftung Ludwig Wien,
       Vienna, Austria
2000: *Contact*, Freiburg Contemporary Art Center, Freiburg, Switzerland
       *Over the Edges*, S.M.A.K., Gent, Belgium
       *The 5th Lyon Biennale*, Lyon, France
       *Fuori Uso 2000 (The Bridges) Art on the Highway*, Piazza Unione, Pescara, Italy
       *I Love Dijon*, Le Consortium Centre d'Art Contemporain, Dijon
       *As it is*, Ikon Gallery, Birmingham, UK
       *The Gift of Hope*, Museum of Contemporary Art, Tokyo
2001: *2nd Berlin Biennale*, Berlin, Germany
       *Target Art in the Park*, Madison Square Park, New York
       *Il Dono*, Pallazzo delle Papesse, Centro Arte Contemporaneo Siena, Siena, Italy
       *Yokohama 2001: International Triennale of Contemporary Art*, Yokohama, Japan

# ROGUES'  GALLERY

## Yasuhiko  HAMACHI

**Born:** 1970, Osaka
**Lives and works:** Osaka

## Yukihisa  NAKASE

**Born:** 1971, Kobe
**Lives and works:** Osaka

**Recent Solo Exhibitions:**
1999: *Audio Picnic at the Museum 3/10*, The Otani Memorial Museum, Nishinomiya, Japan
2000: *Gasoline Music & Cruising*, Los Angeles, USA

**Recent Group Exhibitions:**
2001: *From the Sea of Trees Philippines / Japan*, Ashiya City Museum of Art & History, Ashiya, Japan

# SHIMABUKU

**Born:** 1969, Kobe
**Lives and works:** Yokohama

**Selected Recent Solo Exhibitions:**
1999: *I'm travelling with a 165-metre mermaid*, DAZIBAO, Montreal, Canada
       *Christmas in the Southern Hemisphere*, Air de Paris, Paris, France
2001: *The Octopus Returns*, Kobe Art Village Center; Suma Rikyu Park, Japan

**Selected Recent Group Exhibitions:**
1999: *And / Or*, Grazer Kunstverein, Graz, Austria
       *Space*, Witte de With, Rotterdam, The Netherlands
       *Ivress*, Ateliers d'Artistes de la Ville de Marseille, Marseille, France
       *Extra et Ordinaire*, Printemps de Cahors, Cahors, France
       *Empty Garden*, Watari-Um, The Watari Museum of Contemporary Art, Tokyo
2000: *Elysian Fields*, Centre Georges Pompidou, Paris
       *Counter-Photography*, Moscow, Russia
       *As it is*, Ikon Gallery, Birmingham, UK
       *Transformer*, Raum Aktueller Kunst Martin Janda, Vienna, Austria
       *do it digital*, Kassel, Germany
       *The Gift of Hope*, Museum of Contemporary Art, Tokyo
2001: *Encounter*, Tokyo Opera City Art Gallery, Tokyo
       *The Beginning of Things - The 6th Kitakyusyu Biennale*, Kitakyusyu Municipal Museum of Art,
       Kita Kyusyu, Japan
       *Ikiro-be alive*, Kröller-Müller Museum, Otterlo, The Netherlands
       *Traveller's Tale*, Institute of International Visual Arts (inIVA), London, UK; *Yokohama
       Triennale*, Yokohama, Japan

**Selected Recent Projects:**
1999: *Continuing research for 'Mountains and valleys never meet, but people do'* Netherlands,
       Kyusyu, Japan
2001: web project, Dia Center for the Arts, New York, USA

# Yoshihiro SUDA

**Born:** 1969, Yamanshi
**Lives and works:** Tokyo

**Recent Solo Exhibitions:**
1999: *Ma*, Gallery Koyanagi, Tokyo, Japan
       Galerie Wohn Maschine, Berlin, Germany
2000: Galerie René Blouin, Montreal, Canada
       D'Amelio Terras, New York, USA
2001: Entwistle, London, UK

**Recent Group Exhibitions:**
1999: *Installations by Asian Artists*, Mattress Factory, Pittsburgh, USA
2000: *Vacant Space*, Toyota City Museum, Nagoya, Japan

*Greenhouse Effect*, Serpentine Gallery, London, UK
*Contemporary Japanese Art*, Haus am Waldsee, Berlin, Germany; Kunsthalle Baden, Baden,
Germany; La Biennale de Montreal, Montreal
2001:   *Elusive Paradise*, National Gallery of Canada, Ottawa, Canada
        *'?'*, KIASMA, Helsinki, Finland
        *Standard*, Naoshima Contemporary Art Museum, Naoshima, Japan
        *Space Jack!*, Yokohama Portside Gallery, Yokohama, Japan

# Hiroshi  SUGIMOTO

**Born:** 1948, Tokyo
**Lives and works:** New York

## Selected Recent Solo Exhibitions:
1999:   Galerie Fiedler, Cologne, Germany
        Galerie Meyer-Ellinger, Frankfurt am Main, Germany
        Galerie Camargo Vilaca, Sao Paolo, Brazil
        Galerie Nachst St Stephan, Vienna, Austria
        Gallery Koyanagi, Tokyo, Japan
        Sonnabend Gallery, New York, USA
        Galerie Claude Berrie, RENNE, Paris, France
        *Hiroshi Sugimoto: In Praise of Shadows*, CCA Kitakyushu, Japan
2000:   Deutsche Guggenheim Berlin, Berlin, Germany
        Guggenheim Museum Bilbao, Bilbao, Spain
        The Japan Foundation, Instituto Giapponese di Cultura in Rome, Rome, Italy
        Fraenkel Gallery, San Francisco, USA
        Gallery Koyanagi, Tokyo
        Sonnabend Gallery, New York
        *Modernism*, Gallery Koyanagi, Tokyo
2001:   *Hiroshi Sugimoto*, Kunsthaus Bregenz, Bregenz, Germany
        *No such thing as time*, Dia Center for the Arts, New York
        *Sugimoto Portrait*, White Cube$^2$, London, UK

## Selected Recent Group Exhibitions:
1999:   *Regarding Beauty*, Hirschorn Museum, Washington DC, USA
        *Views from the Edge of the World*, Marlborough Gallery, New York
        *Glen Dimplex Award*, Irish Museum of Modern Art, Dublin, Ireland
        *Autour de L'insolite*, Modernism Gallery, San Francisco
        *Tomorrow for Ever - Photography as a Ruin*, Kunsthalle, Krems, Austria
        *As Far as the Eye Can See*, The Atlanta College of Art Gallery, Atlanta, USA
        *Asia Pacific Triennale*, Queensland Art Gallery, Brisbane, Australia
2000:   *LUX*, Lucas Shoomans, New York
        *Architecture Without Shadows*, Centro Andaluz de Arte Contemporaneo, Seville, Spain
        *Between Body and Space*, Ujazdowsky Castle, Warsaw, Poland
        *Continental Shift*, Ludwig Forum, Aachen, Germany
2001:   *Give & Take*, Serpentine Gallery and Victoria & Albert Museum, London

## Tadasu **TAKAMINE**

**Born:** 1968, Kagoshima
**Lives and works:** Ogaki, Gifu

**Recent Solo Exhibitions:**
2000:   Voice Gallery, Kyoto, Japan

**Recent Group Exhibitions:**
1999:   *GENDAI*, Glen Eira City Gallery, Glen Eira, Australia
        *SKIN DIVE*, Tatsuike Primary School, Kyoto, Japan
        *Images Festival of Independent Film & Video*, Vtape, Toronto, Canada
        *Media City*, Artcite, Windsor, Canada
2000:   *Fuyu-no-Umi*, CAI (Contemporary Art Institute), Sapporo, Japan
        *Confessions of a Voyeur*, Dulcinea, Bodrum Kat, Istanbul, Turkey
2001:   *EXIT*, Cretail Maison des Arts, Paris, France

**Recent Performances:**
1999:   *Consilience* (collaboration with P. Bodin), Banff Center for the Arts, Banff, Canada
        *K.I.T.*, ICC InterCommunication Center, Tokyo, Japan

## Atsuko **TANAKA**

**Born:** 1932, Osaka
**Lives and works:** Asuka Nara

**Recent Solo Exhibitions:**
1999:   *Tanaka Atsuko 1998-2000. Recent Works*, Gallery HAM, Nagoya, Japan
2001:   Ashiya Museum, Hyogo, Japan
        Shizuoka Prefectural Museum of Art, Shizuoka, Japan

**Recent Group Exhibitions:**
1999:   *Out of Actions: between performance and the object, 1949-1979*, Museum of Contemporary Art,
        Tokyo, Japan
        *Art / Domestic*, Steagaya Art Museum, Tokyo
        *Gutai*, Galerie nationale du Jeu de Paume, Paris, France
2000:   *Force Fields: Phases of the Kinetic*, Museu d'Art Contemporani de Barcelona, Barcelona,
        Spain; Hayward Gallery, London, UK

## Yuji **WATABE**

**Born:** 1974, Mie
**Lives and works:** Tokyo

**Recent Solo Exhibitions:**
1999:   Westbeth Gallery Kozuka, Nagoya, Japan
2000:   Westbeth Gallery Kozuka, Nagoya
2001:   Westbeth Gallery Kozuka, Nagoya

Recent Group Exhibitions:
1999:   *Maeda Studio - readystarted*, CCA Kitakyushu, Kitakyushu, Japan
2000:   *Here, Now*, Fukuoka Art Museum, Fukuoka, Japan
        *Open studio*, CCA Kitakyushu Fukuoka, Kitakyushu
        *Philip Morris Art Award 2000*, Tokyo
        *Maeda-Studio*, CCA Kitakyushu, Kitakyushu
        *Café, canolfan - readystarted 2*, Nagoya
2001:   *Artists' Debut*, Rice Gallery, Tokyo
        *Open studio*, CCA Kitakyusu, Kitakyushu

# Go  **W A T A N A B E**

**Born:** 1975, Hiroshima
**Lives and works:** Kitakyushu

**Selected Recent Group Exhibitions:**
1999:   *Maeda Studio*, CCA Kitakyushu, Kitakyushu, Japan
        *Cities on the Move*, Hayward Gallery, London, UK
        *Port People*, Boko Garage Gallery, Nagoya, Japan
        *Seven's Door*, Laforet Harajyuku kokura, Kitakyushu
        *2shot service*, gallery SOAP, Kitakyushu
        *Open Studio*, CCA Kitakyushu, Kitakyushu
2000:   *Artists' Debut*, Rice Gallery, Tokyo, Japan
        *screening Japan*, Hallo!, Copenhagen, Denmark
        *Dream On*, Laforet Harajyuku kokura, Kitakyushu
        *Open Studio*, CCA Kitakyushu, Kitakyushu
        *here.now. 2000-1997*, Fukuoka city museum, Fukuoka, Japan
2001:   *Transit*, Laforet Harajyuku kokura, Kitakyushu

# Shigenobu  **Y O S H I D A**

**Born:** 1958, Iwaki City
**Lives and works:** Iwaki City

**Recent Solo Exhibitions:**
2000:   *Hikosaka Naoyoshi prize, Bio-Morph May 1-7, 2000*, Tokyo Gallery, Tokyo, Japan
        *Exhibition Space*, Tokyo International Forum, Tokyo

**Selected Recent Group Exhibitions:**
1999:   *ART-ING TOKYO 1999: 21 x 21"*, Saison Art Program / Gallery Gen, Tokyo
2000:   *Beyond the Boundary*, Iwaki City Art Museum, Iwaki, Japan
2001:   *Art @ Children's Center*, Iwado Children's Centre, Komae, Japan

**Recent Workshops:**
1999:   The National Museum of Western Art, Tokyo
2000:   Mimaya Elementary School, Iwaki
        Tokyo International Forum, Tokyo
2001:   Iwado Children's Center, Komae

# FURTHER READING

## Solo exhibition catalogues

*Yukio Fujimoto: Ears of the Rooftop*, Kodama Gallery, Osaka, 1990

*Takehisa Kosugi*, daadgalerie, Berlin, 1992

*Motion Pictures by Sugimoto*, Galleria APSAS Locarno, Locarno, 1995

*The Adventures of Akasegawa Genpei*, Nagoya City Art Museum, Nagoya City, 1995
(in Japanese)

*Sugimoto*, Contemporary Arts Museum, Houston / Hara Museum of Contemporary Art, Tokyo, 1996

*Takehisa Kosugi: World of Sound, The New Summer*, Ashiya City Museum of Arts and
History, Hyogo, 1996

*Tatsuo Miyajima: Big Time*, Modern Art Musuem of Fort Worth, Fort Worth, 1996 / Hayward
Gallery, London, 1997

*Time House: Tatsuo Miyajima*, Oakville Galleries, Oakville, 1996

*Love Forever: Yayoi Kusama, 1958-1968*, Los Angeles County Museum of Art, Los Angeles /
Japan Foundation, Tokyo / The Museum of Modern Art, New York, 1998

*Yukio Fujimoto. Object, Installations and Performances*, Otani Memorial Art Musuem;
Nishinomiya City, 1998

*Araki Nobuyoshi: Sentimental Photography, Sentimental Life*, Museum of Contemporary Art
Tokyo, Tokyo, 1999

*Hiroshi Sugimoto: In Praise of Shadows*, Center of Contemporary Art (CCA), Kitakyushu, 1999

*Shimabuku. I'm traveling with a 165-meter mermaid / Je voyage avec une sirene de 165
metres*, Dazibao, Montreal, 1999

*Tatsuo Miyajima MEGA DEATH: shout! shout! count!*, Tokyo Opera City Art Gallery, 1999

*Nobuyoshi Araki: Viaggio Sentimentale*, Centro per l'Arte Contemporanea Luigi Pecci,
Prato, 2000

*Atsuko Tanaka: Search for an Unknown Aesthetic, 1954-2000*, Ashiya City Museum of Art
and History, Ashiya City, 2001

*Nobuyoshi Araki: Tokyo Still Life*, Ikon Gallery, Birmingham, 2001

*Noguchi Rika: a feeling of something happening*, Marugame Genichiro - Inokuma Museum of
Contemporary Art, Marugame, 2001

*Seeing Birds. Rika Noguchi*, P3 art and environment, Tokyo, 2001

*Shimabuku 2001*, Kobe Art Village Center, Kobe, 2001

## Group exhibition catalogues

*Reconstruction: Avant-garde Art in Japan 1945-1965*, Museum of Modern Art, Oxford, 1985
*Japon des Avant-gardes*, Centre National de George Pompidou, Paris, 1986
*Out of Action: between performance and the object, 1949-1979*, The Museum of Contemporary Art, Los Angeles / Thames and Hudson, Inc., New York, 1988
*Japanese Art after 1945: Scream against the Sky*, Guggenheim Museum, New York, 1994
*Addressing the Century: 100 Years of Art & Fashion*, Hayward Gallery Publishing, 1998
*11th Biennale of Sydney: everyday*, the Biennale of Sydney Ltd., 1998
*A Sense of Reality*, Utsunomiya Museum of Art, Utsunomiya-shi, 1999
*Extra et Ordinaire, Printemps de Cahors*, Cahors, 1999
*From #1*, Witte de With, 1999
*Giappone - XLVIII Biennale de Venezia*, The Japan Foundation, Tokyo, 1999
*Anti-Memory: Contemporary Photography II*, Yokohama Musuem of Art, Yokohama, 2000
*As It Is*, Ikon Gallery, Birmingham, 2000
*Portraits*, Guggenheim Museum, New York, 2000
*Encounter*, Tokyo Opera City Art Gallery, Tokyo, 2001
*The Gift of Hope*, Museum of Contemporary Art, Tokyo, 2001

## Other

Fineberg, J., *'Gutai', Art Since 1940, Strategies of Being* (Second Edition), Laurence King, London, 2000, pp.176-177
Kaijima, M., (trans. Hayashi, S.), 'Ways of Looking at the Suburban Landscape', and Miyadai, Shinji (trans. AcKnight, A.), 'In the very fact of an intensity without having "meaning"', *Homma, Takashi: Tokyo Suburbia*, Korinsya Press & Co., Ltd., 1998
Kaprow, A., 'Nine Japanese of the Gutai Group', *Assemblage, Environments & Happenings*, Harry N. Abrams, Inc., New York, 1966, pp. 211-225
Nomura, M., 'Follow Children's Music; the fundamental idea', *The British Journal of Music Foundation*, vol.13, Cambridge University Press, Cambridge, 1996, pp.203-224
Nomura, M., *Rojo Nikki (Diary on the Road)*, Atelier Peyotl Inc., 1999 (in Japanese)
*Ryuji Miyamoto*, Steidl Publishers, Germany, 1999

# LIST OF WORKS

## Genpei AKASEGAWA

**1**
*Mysterious Objects in England*, 1985
27 photographs (C-prints)
dimensions variable
Collection of the artist
Courtesy of Shiraishi Contemporary Art

**2**
*Diary*, 1985
mixed media
dimensions variable
Collection of the artist
Courtesy of Heibonsha, Shiraishi Contemporary Art

**3**
*Diary*, 1984-86
21 hand written diary pages with drawings -
paper, pencil, pen
each 29.5 x 21 cm
Collection of the artist
Courtesy of Nagoya City Art Museum / Shiraishi
Contemporary Art

## Nobuyoshi ARAKI

**4**
*Tokyo Nostalgy*, 1985-93
black and white photographs
each 11.5 x 16.5 cm
Collection of the artist
Courtesy of Yoshiko Isshiki

**5**
*Flowers*, 1998
colour copies
each 110.3 x 75 cm
Collection of the artist
Courtesy of Yoshiko Isshiki

## Yukio FUJIMOTO

**6**
*Hermetic Scale (Diameter)*, 1988
wood, china, musical movement
30 x 120 x 10 cm
Collection of the artist
Courtesy of Otani Memorial Art Museum,
Nishinomiya City
photo: Kiyotoshi Takashima

**7**
*Ears with Chair, Ear Pipe - Inside Version*, 1990
mixed media - vinyl, chloride, wood, iron, chair
dimensions variable
Collection of the artist
Courtesy of Otani Memorial Art Museum, Nishinomiya City

**8**
*Ears with Chair, Ear Pipe - Outside Version*, 1990
mixed media - vinyl, chloride, wood, iron, chair
dimensions variable
Collection of the artist
Courtesy of Otani Memorial Art Museum, Nishinomiya City

**9**
*King & Queen*, 1990
wood, sand, clock
6 x 7 x 7 cm
Collection of the artist
Courtesy of Otani Memorial Art Museum, Nishinomiya City

**10**
*Echo (A Right Angled)*, 1997
mirror
10 x 10 x 10 cm
Collection of the artist
Courtesy of Otani Memorial Art Museum, Nishinomiya City

**11**
*Cosmos (Black)*, 1998
glass, plastic, dice, iron, cork, musical movement
15 x 20 x 6 cm
Collection of the artist
Courtesy of Otani Memorial Art Museum, Nishinomiya City
photo: Kiyotoshi Takashima

**12**
*There*, 1998
door scope, iron
180 x 10 x 10 cm
Collection of the artist
Courtesy of Otani Memorial Art Museum, Nishinomiya City
photo: Kiyotoshi Takashima

**13**
*Record*, 2001
record disk, aluminium, brush, motor
10 x 30 x 30
Collection of the artist
Courtesy of Otani Memorial Art Museum, Nishinomiya City
photo: Kiyotoshi Takashima

**14**
*Room (London)*, 2001
electronic keyboards
4 parts: 15 x 100 x 40; 10 x 80 x 30;
10 x 70 x 25; 10 x 60 x 25 cm
Collection of the artist
Courtesy of Otani Memorial Art Museum, Nishinomiya City

## Takashi HOMMA

**15**
*Children of Tokyo*, 2000-01
digital colour prints
each approx. 450 x 350 cm
Courtesy the artist

## Takefumi ICHIKAWA

**16**
*Fuyu '01*, 2001
special film, helium gas, air
2-3 pieces, each 200 x 100 x 100 cm
Courtesy the artist

## Tomoko ISODA

**17**
*Afterimage*, 1997
gelatin-silver print
32.6 x 48.8 cm
Collection of the artist

**18**
*Afterimage*, 1998
gelatin-silver print
32.6 x 48.8 cm
Collection of the artist

**19**
*Untitled*, 1999
gelatin-silver print
25.3 x 38.2 cm
Collection of the artist

**20**
*Untitled*, 1999
gelatin-silver print
25.3 x 38.2 cm
Collection of the artist

**21**
*Untitled*, 1999
gelatin-silver print
25.3 x 38.2 cm
Collection of the artist

**22**
*Untitled*, 1999
gelatin-silver print
25.3 x 38.2 cm
Collection of the artist

**23**
*Untitled*, 1999
gelatin-silver print
25.3 x 38.2 cm
Collection of the artist

**24**
*Untitled*, 1999
gelatin-silver print
25.3 x 38.2 cm
Collection of the artist

**25**
*Untitled*, 1999
gelatin-silver print
25.3 x 38.2 cm
Collection of the artist

**26**
*Afterimage*, 2000
gelatin-silver print
32.6 x 48.8 cm
Collection of the artist

**27**
*Afterimage*, 2000
gelatin-silver print
32.6 x 48.8 cm
Collection of the artist

**28**
*Afterimage*, 2000
gelatin-silver print
32.6 x 48.8 cm
Collection of the artist

## Takehisa KOSUGI

**29**
*Stream*, 1993
AM/FM radio, multi-sound modulator, audio
mixer, delay machine, amplifier, loud speaker,
transformer, cable, plastic tubes, wooden box
1,000 cm (wide)
Courtesy the artist
Photo by Kiyotoshi Takashima,
courtesy Utsunomiya Museum of Art

**30**
*Interspersion for Light and Sound*, 2000
electronic sound oscillator, LED, pezo speaker,
battery, white sand, plexi box, wooden plinth
32 x 24 x 5.5 cm
Courtesy the artist

## Yayoi KUSAMA

**31**
*Narcissus Garden*, 1966 (reconstructed in 2001)
1500 silver balls
17 cm diameter each
Collection of the artist
Courtesy of Ota Fine Arts, Tokyo

**32**
*Song of a Manhattan Suicide Addict*, 2001
projected video (DVD) with sound
Running time: 51 seconds
Collection of artist
Courtesy of Ota Fine Arts, Tokyo

## Tomomi MAEKAWA

**33**
*4:30*, 1999
oil and acrylic on canvas
120 x 120 cm
Collection of the artist
Courtesy Ota Fine Arts, Tokyo

**34**
*F-15DJ*, 2000
acrylic on canvas
112 x 162 cm
Private Collection

**35**
*UH-60J*, 2000
acrylic on canvas
120 x 120 cm
Private Collection

**36**
*UH-60J*, 2000
acrylic on canvas
80.5 x 116.5 cm
Collection Kazunori Saito

**37**
*3:00*, 2000
oil and acrylic on canvas
89.5 x 130 cm
Collection of the artist
Courtesy Ota Fine Arts, Tokyo

**38**
*14:00*, 2000
acrylic on canvas
130 x 194 cm
Collection of the artist
Courtesy Ota Fine Arts, Tokyo

**39**
*12:00*, 2001
acrylic on canvas
112 x 162 cm
Collection Masaaki Ogura

**40**
*15:30*, 2001
acrylic on canvas
120 x 120 cm
Collection Ryutaro Takahashi

## Tatsuo MIYAJIMA

**41**
*Floating Time, V2-06-Dark Grey*, 2000
installation with CG software, projector,
PC and darkroom
dimensions variable
Collection Fuji Television Gallery
Photo: Norihiro Ueno

## Ryuji MIYAMOTO

**42**
*Pin hole houses*, 2000
installation with photographs
3 houses, each 165 x 186 x 94 cm
Courtesy the artist

**43**
*Inside Out, Upside Down*, 2001
photograph
3 parts, total 230 x 166 cm
Collection of the artist

**44**
*Inside Out, Upside Down*, 2001
photograph
5 parts, total 320 x 230 cm
Collection of the artist

**45**
*Inside Out, Upside Down*, 2001
photograph
5 parts, total 320 x 230 cm
Collection of the artist

**46**
*Inside Out, Upside Down*, 2001
photograph
10 parts, total 320 x 640 cm
Collection of the artist

**47**
*Inside-out-Upside-down, Takeshita St., Tokyo*, 2001
video on monitor (DVD) with sound
Running time: 60 minutes
Collection of the artist

## Yukio NAKAGAWA

**48**
*Flower is the Mystic Mountain*, 1989 (remade 2001)
photograph
260 x 340 cm (consisting of 3 panels)
Courtesy the artist

## Rika NOGUCHI

**49**
*#12 Untitled* – from *A Prime* series, 1999
photograph
140 x 110 x 5 cm
Collection of the artist. Courtesy Gallery Koyanagi

**50**
*#13 Untitled* – from *A Prime* series, 1999
photograph
140 x 110 x 5 cm
Collection of the artist. Courtesy Gallery Koyanagi

**51**
*#14 Untitled* – from *A Prime* series, 1999
photograph
140 x 110 x 5 cm
Collection of the artist. Courtesy Gallery Koyanagi

**52**
*#15 Untitled* – from *A Prime* series, 1999
photograph
140 x 110 x 5 cm
Collection of the artist. Courtesy Gallery Koyanagi

**53**
*#1 Untitled* – from *New Land* series, 1999
photograph
100 x 100 x 5 cm
Collection of the artist. Courtesy Gallery Koyanagi

**54**
*#2 Untitled* – from *New Land* series, 1999
photograph
100 x 100 x 5 cm
Collection of the artist. Courtesy Gallery Koyanagi

**55**
*#3 Untitled* – from *New Land* series, 1999
photograph
100 x 100 x 5 cm
Collection of the artist. Courtesy Gallery Koyanagi

**56**
*#4 Untitled* – from *New Land* series, 1999
photograph
100 x 100 x 5 cm
Collection of the artist. Courtesy Gallery Koyanagi

**57**
*#5 Untitled* – from *New Land* series, 1999
photograph
100 x 100 x 5 cm
Collection of the artist. Courtesy Gallery Koyanagi

**58**
*#6 Untitled* - from *New Land* series, 1999
photograph
100 x 100 x 5 cm
Collection of the artist. Courtesy Gallery Koyanagi

**59**
*#7 Untitled* - from *New Land* series, 1999
photograph
100 x 100 x 5 cm
Collection of the artist. Courtesy Gallery Koyanagi

**60**
*#8 Untitled* - from *New Land* series, 1999
photograph
100 x 100 x 5 cm
Collection of the artist. Courtesy Gallery Koyanagi

**61**
*#9 Untitled* - from *New Land* series, 1999
photograph
100 x 100 x 5 cm
Collection of the artist. Courtesy Gallery Koyanagi

## Makoto NOMURA

**62**
Performance, 2001
mixed media

## Navin RAWANCHAIKUL

**63**
*Shakespeare in Taxi*, 2000
Austin black taxi cab with acrylic paint
dimensions variable
Courtesy Ikon Gallery

**64**
*Shakespeare in Taxi*, 2000
48 page comic book
Courtesy Ikon Gallery

## Rogues' GALLERY

**65**
*Residual Noise / A car two persons' driving*, 2001
car, sounds of car, microphones, mixer,
oscillator, effectors, power amplifier,
speakers, sub-ufers
dimensions variable
© Rogues Gallery 2001

## SHIMABUKU

**66**
*Then, I decided to give a tour of Tokyo
to the Octopus from Akashi*, 2000
video projection (DVD) with sound
Running time: 5 minutes
Collection of the artist
Cooperation: Mizukami Hidekazu, Matsushita Masumi
and Sugeno Hiroaki

**67**
*Man trying to catch a bird with his eyes
covered*, 2001
video (DVD) with sound
Collection of the artist
Cooperation: Rika Noguchi

## Yoshihiro SUDA

**68**
*Warsaw Rose*, 2000
painted wooden sculpture
dimensions variable
Collection of the artist
Courtesy Gallery Koyanagi, Tokyo
and Galerie Wohnmaschine Berlin

**69**
*One Hundred Encounters*, 2001
painted wooden sculpture
dimensions variable
Collection of the artist
Courtesy Gallery Koyanagi, Tokyo
and Entwistle, London

## Hiroshi SUGIMOTO

**70**
*In Praise of Shadows*, 2001
7 lithographs
each 76 x 57 cm
Collection of the artist
Courtesy Gallery Koyanagi

**71**
*Accelerated Buddha*, 1997
VHS video projection with sound
Running time: 5 minutes
Collection of the artist
Courtesy Gallery Koyanagi

## Tadasu TAKAMINE and Masashi IWASAKI

**72**
*Inertia*, 1998
video projection (DVD) with sound
Running time: 6 minutes
Collection of the artists
© Tadasu Takamine & Masashi Iwasaki, 2001

## Atsuko TANAKA

**73**
*1985A*, 1985
acrylic lacquer on canvas
218.5 x 333.3 cm
Collection of the Shizuoka Prefectual Museum of Art

**74**
*'87II*, 1987
acrylic lacquer on canvas
193.7 x 257.5 cm
Collection of Ashiya City Museum of Art & History

**75**
*WORK '91A*, 1991
acrylic lacquer on canvas and plywood
200 diameter cm
Collection of Ashiya City Museum of Art & History

**76**
*'99I*, 1999-2000
acrylic lacquer on canvas
188.5 x 130.5 cm
Collection of the artist

**77**
*'94B*, 1994
acrylic lacquer on canvas
300 x 510 cm
Collection of the artist

## Yuji WATABE

**78**
*Ghost (wall drawings)*, 2001
pencil
dimensions variable

## Go WATANABE

**79**
*Drill Man*, 1998
VHS video installation with mixed media
Running time: 20 minutes
Collection of the artist

**80**
*Clean up*, 1999
VHS video installation with mixed media
Running time: 30 minutes
Collection of the artist

## Shigenobu YOSHIDA

**81**
*London-Penzance*, 2001
projected video (DVD)
Running time: 120 minutes
Collection of the artist

# ACKNOWLEDGEMENTS

Yuji Akimoto; Taro Amano, Yokohama Museum of Art; Stanley N. Anderson; Shigeru Ban; Sophie Branscombe; Kevin E Consey, Berkeley Art Museum/Pacific Film Archive; Hitoshi Dehara, Hiroshima City Museum of Contemporary Art; Kyoko Ebata; Kumiko Ehara, Benesse House, Naoshima Contemporary Art Museum; Entwistle, London; Fuji Television Gallery; Judith and Richard Greer; Philip Gumuchdjian; Hisako Hara; Toshio Hara, Hara Museum of Contemporary Art; Yukiko Harada and Yoshiko Mori, Mori Art Center; Yuko Haseagawa, formerly of Setagaya Art Museum and now of Contemporary Art Museum, Kanazawa; Yoko Higuchi; Itaru Hirano, The Museum Of Modern Art, Saitama; Masanori Ichikawa, Kazuo Nakabayashi, Kiyohisa Nishizaki and Koji Takahashi, National Museum of Modern Art, Tokyo; Takako Ikamoto, HEAR sound art library; the staff and board of Ikon Gallery, Birmingham; Chie Ishii, Fukuoka City Foundation for Arts and Cultural Promotion; Arata Isozaki and Aiko Miyawaki Isozaki; Yoshiko Isshiki; Jinno Kimio Ito, Gallery HAM, Nagoya; Yukiko Ito, Creative Union Hiroshima; Kyoko Jimbo, Tokyo Metropolitan Museum of Photography; Akira Kanayama; Michiko Kasahara, Tokyo Metropolitan Museum of Photography.

Mami Kataoka, Art Gallery Tokyo Opera City Cultural Foundation; Mikako Kato, Kenji Taki Gallery; Mizuho Kato, Ashiya City Museum of Art & History; Tomomi Kato; Takahiko Katsumata, Embassy of Japan; Chizuru Kawanami, Fukuoka Prefectural Museum of Art; Koichi Kawasaki, Ashiya City Museum of Art & History; Tomomi Kimata; Hiroma Kitzawa, Nanjo and Associates; Kikiyoshi Kodama; Shinji Kohmoto, The National Museum of Modern Art, Kyoto; Yayoi Kojima; Hiraku Kore-eda, Sezon; Tomio Koyama; Atsuko Koyanagi, Gallery Koyanagi, Koyanagi Fine Art, Tokyo; Shino Kuraishi, Yokohama Museum of Art; Raiji Kuroda; Anna Lopriore; Roger McDonald; Paddy McGowan, igse Carlow Arts Festival; Yusuke Minami, Museum of Contemporary Art, Tokyo; Chisa Misaka; Akiko Miyake; Daisuke Miyatsu, Promotion Division, Kokurensha Inc.; Mitsuru Mizutani; Emanuelle de Montgazon, Attaché Culturel, Ambassade de France, Tokyo; Minister Masatoshi Muto; Yoshihiro Nakatani; Fumio Nanjo; Taeko Nanpei; Ryu Nimi, Sezon Museum of Art, Tokyo (1997); Counsellor Shinichi Nishimiya, Director, Japan Information and Cultural Centre/Joint Chief Executive of Japan 2001; Natsuko Odate; Masaaki Ogura; Mariko Oikawa; Keiko Okamura, Museum of Contemporary Art, Tokyo; Naomasa Okumura; Eriko Osaka, Mito Arts Foundation; Seiji Oshima, Setagaya Art Museum; Hidenori Ota, OTA Fine Arts; Otani Memorial Art Museum, Nishinomiya City; Yuka Otsuka; Yuko Ozawa, Nanjo and Associates; Christopher Purvis, Joint Chief Executive of Japan 2001; Kazunori Saito; Tadayasu Sakai, Museum of Modern Art, Kamakura; Takeshi Sakurai, British Council, Tokyo (1997); Hiroaki Sano, Embassy of Japan; Shugo Satani; Keiko Shimada; Yamano Shingo, Museum City Project; Junichi Shioda, Museum of Contemporary Art, Tokyo; Masami Shiraishi and Maho Kubota, Shiraishi Contemporary Art Inc; The Shizuoka Prefectural Museum of Art; Nozomi Takagi, Fukuoka Asian Art Museum; Ryutaro Takahashi; Professor Shuji Takashina, National Museum of Western Art, Tokyo; Kenji Taki, Kenji Taki Gallery; Akio Tokunaga, Fukuoka City Foundation for Arts and Cultural Promotion; Kyoichi Tsuzuki; Yoko Uchida; Masahiro Ushiroshoji, Fukuoka Asian Art Museum; Utsunomiya Museum of Art; Voice Gallery; Johnnie Walker, Project Director, Tate Tokyo Residency; Etsuko Watari and Shizuko Watari, The Watari Museum of Contemporary Art; Koichi Watari; Ben Weaver, General Assembly Ltd.; Miho Yajima; Satoshi Yamada, Nagoya City Art Museum; Shigeo Yamada, Embassy of Japan; Yozo Yamaguchi, Fukuoka City Art Museum; Atsuo Yamamoto, Ashiya City Museum of Art & History; Kazuo Yamawaki, Nagoya City Museum; Yokohama Museum of Modern Art.